IMAGES
of Modern America

SEATTLE
CHOCOLATIERS

IMAGES
of Modern America

SEATTLE
CHOCOLATIERS

Cornelia Gallen-Kimmell and
Cordula Drossel-Brown, PhD,
with photography by Kathy Robinson

ARCADIA
PUBLISHING

Published by Arcadia Publishing
Charleston, South Carolina

Printed in the United States of America

Library of Congress Control Number: 2015943071

For all general information, please contact Arcadia Publishing:
Telephone 843-853-2070
Fax 843-853-0044
E-mail sales@arcadiapublishing.com
For customer service and orders:
Toll-Free 1-888-313-2665

Visit us on the Internet at www.arcadiapublishing.com

*To the chocolatiers and chocolate experts who shared
their wisdom and delighted us with their stories and
confections, and to our families for their support*

CONTENTS

ACKNOWLEDGMENTS

A big thank you to all the chocolatiers, chocolate experts, and chocolate lovers we met while writing this book. Thank you for your time and for sharing your stories, your passion, and your wonderful confections with us.

Thank you to Dr. Kristy Leissle for your expertise and deep knowledge about all things chocolate. Thank you to Matt Todd, title manager, and to Sara Miller, production editor, both at Arcadia Publishing, for your support and guidance.

We wish to thank Kathy Robinson, our dedicated photographer, chocolate taster, and weekend road-trip companion. This book would not have come together without you!

We also wish to thank Arcadia Publishing for giving us the opportunity to explore this delicious topic and write a book about it.

Thank you also to friends and colleagues, both here and in Germany, who gave insights, comments, and helpful advice.

And last, but certainly not least, we wish to thank our families—Chris, Emma, and Anna Kimmell and Fearon, Henry, Isabella, and Juliana Brown—for your love and encouragement, for your patience, and for being great listeners, advisers, advocates, and tasters. We appreciate you so much.

Unless otherwise noted, all photographs appear courtesy of Kathy Robinson.

INTRODUCTION

Seattle, long hailed as the "Coffee Capital of the World," is a city with a dynamic and influential artistic and cultural scene and home to the richest, most educated, and probably most laid-back citizens. The city is happily accepting another superlative, its chocolate—as intense as grunge, as successful as Starbucks, as legendary as Hendrix, as regular as rain in Seattle! Our chocolate might be better now than it has ever been.

Chocolate is art, and like any piece of art, one's choice of chocolate is a matter of personal preference and taste. There are trends, as chocolate professionals agree, but it comes down to this: does it taste good to you? There is an evolution of sophistication from the generation that grew up with the proverbial Hershey's Bar to today's Seattleites willing to pay $20 for a bar of chocolate or $8 for one perfect truffle in its own box.

What makes people agree that some of the world's best chocolate comes from Seattle? Names like Dilettante Chocolates and Fran's Chocolates have changed Seattle. Dilettante introduced Mocha Cafés, where patrons were invited to linger over espresso drinks and chocolate. Fran's gently but relentlessly insisted that chocolate can be a pure, superior taste experience, enhanced with a pinch of sea salt. This might have changed the taste buds of the entire nation—over the last 10 years, the chocolate on the American market has become 10 percent darker.

Seattle's laid-back outdoor culture is counterbalanced by a self-confident urban community with fond memories of the Frederick & Nelson tea room and Frango mints, civic pride in the Pike Place Market, and many preservation efforts aiming to keep urban growth connected to the land and its slower traditions.

Seattle is a city with a consciously evolving food vibe—people know where their food comes from, and they care about how it is grown, raised, and harvested. Many of the city's residents are dedicated to community, food, and celebration. The surrounding fertile fields and valleys dictate much of the seasonal offerings in the city's markets. Enthusiasm for backyard, pea-patch, and sidewalk gardening illustrates that Seattleites have a heart for edible beauty. Sunny summer skies entice tourists and residents alike to indulge in the city's offerings; a host of local restaurants cater to these sensibilities. The chocolate scene reflects the city's vibe.

There are multiple reasons why many Seattleites can embrace the finest chocolate. In a region with 8 billionaires and 68,000 millionaires residing in King County alone, not all Seattleites hunt for a bargain; they are willing and able to pay for luxury, including the luxury of superior chocolate.

There are two big chocolate festivals in Seattle, the Seattle Luxury Chocolate Salon (www.seattlechocolatesalon.com), now in its eighth year, and the Northwest Chocolate Festival (www.nwchocolate.com), which started in Portland and is now in its sixth year. When the *Seattle Times* opined in 2009 that "chocolate has been anointed with gourmet status" here, the Seattle chocolate scene was already substantial and established enough to be a hub for educating about and celebrating all things chocolate.

Seattle is home to Theo, the nation's first chocolate factory that manufactures fair-trade and organic chocolate from sustainably sourced beans. Theo's local roasting and chocolate-making started the "from bean to bar" movement. Seattle is home to Fran Bigelow, a member of the global Heirloom Cacao Preservation Initiative Founding Circle (www.finechocolateindustry.org), and to indi Chocolates, the first micro-batch cocoa roaster, which makes its specialty chocolate in the heart of Seattle's Pike Place Market. Seattle merchants stock single-origin chocolate from rare terroir on their shelves, and these feature as bestsellers. Seattle knows that not all chocolate is created equal.

Chocolatiers know their cocoa-growing regions and work with chocolate from all over the world to create confections that incorporate their heritage, personality, temperament, and colors. It speaks to the engineering spirit of Seattle—inventive, dedicated, food-conscious—that Seattle chocolatiers, who come from all corners of the world, are as creative, skilled, and unique as the confections they produce; they truly can educate the palate of the nation.

Trained at the finest culinary programs in the United States and abroad as bakers, confectioners, or chocolatiers; retirees, widows, techies, empty-nesters, career-changers, and immigrants with an eye for opportunity and a heart for their homeland—they all make up Seattle's chocolatier community. Ask a Seattle chocolatier about chocolate, and you may hear an answer close to a lecture about farming in the tropics; heritage cocoa DNA and cloning; geopolitics; slave labor; fair trade and organic farming; and sourcing, roasting, and tempering.

In a program unique to Seattle, courses on chocolate are taught at university level. Since 2001, Bill Fredericks has been teaching the University of Washington Extension classes "Exploring Chocolate" and "Introduction to Truffles." Dr. Kristy Leissle has taught "Chocolate: A Global Inquiry" at the University of Washington–Bothell since 2010.

Seattle's craft chocolatiers take pride in working with their own hands, setting themselves and their artisanal chocolate apart from mass-produced brands. In places across Seattle, from specialty chocolate stores to the chocolate aisle in a supermarket, chocolate-lovers can find chocolates made locally and from all over the world.

No longer just a quick fix for sweet-tooth cravings or a Valentine's Day treat for a sweetheart, chocolate is now socially acceptable and presentable and is making its victorious entrance into the list of superfoods for the nutritionally conscious. It is widely reported that chocolate has a positive impact on health; it may even help people live longer.

Seattle's large harbor delivers cocoa beans and spices from near and far locations, and Seattle chocolatiers combine traditions from all continents to create extravagant taste experiences and flavors from beans harvested in the Caribbean, South America, Africa, and Hawaii. These experiences include treats such as basil-infused truffle bars, blackberry vinaigrette truffles, grey salt caramels, hazelnut in dark ganache enrobed with Colombian dark couverture, lemon confections, jalapeño-spiced truffles, or chili pepper chocolate concoctions—the offerings are limitless.

Visitors and residents alike, try not to let Seattle's drizzle get to you as you enjoy a delicious cup of hot chocolate, savor a few pieces of exquisite chocolate or one or two mouthwatering truffles, take a chocolate-making class, go on a chocolate tour, visit a chocolate factory, or attend a chocolate lecture or a chocolate conference. Our book will be your guide to Seattle's chocolate world.

One

NORTHWEST CHOCOLATE FESTIVAL

NORTHWEST CHOCOLATE FESTIVAL. Fall in Seattle heralds an annual two-day fair that showcases "chocolate from farm, to bar, and beyond." Fine craft chocolate makers, pastry chefs, and confection artisans from around the world participate, offering 60-plus workshops and lectures with topics covering a wide range of subjects. Festivalgoers can sample exquisite chocolate concoctions, and the serious student can eagerly learn everything about *Theobroma cacao*, the "food of the gods."

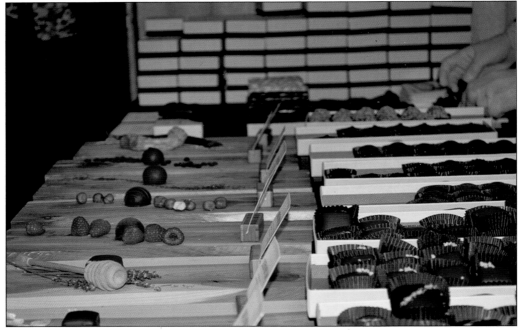

FINE CHOCOLATE ART. Here, truffle-making is being demonstrated at the Northwest Chocolate Festival by a chocolatier displaying the natural ingredients used to flavor the ganache. Infusing the chocolate with the essence of, for example, lavender, raspberries, hazelnuts, or ginger root speaks to the ingenuity and fine craftsmanship of the chocolatier. Hand-crafted truffles beg to be sampled.

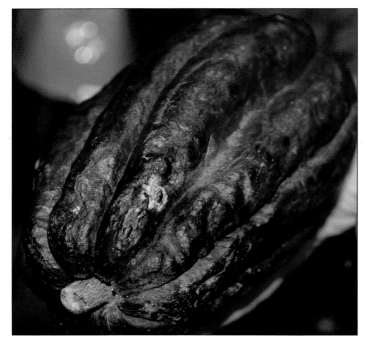

THE COCOA POD. Not always beautiful in appearance, it is the one and only basic ingredient for all heavenly things chocolate. "Taste the Fruit of the Cocoa Tree," a Northwest Chocolate Festival workshop led by the Pacific Northwest's own "Chocolate Man," Bill Fredericks, explains the chemistry and mechanics of producing chocolate. The festival expands global and interdisciplinary understanding of chocolate.

Two

SEATTLE'S EARLY CHOCOLATIERS

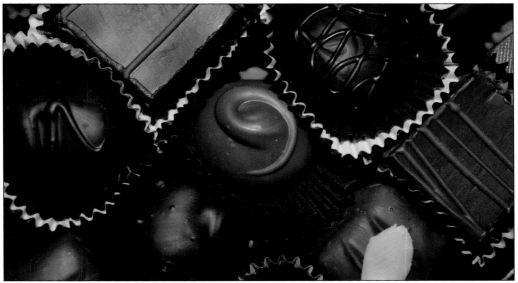

SEATTLE'S EARLY CHOCOLATIERS. Innovators brought European-style taste and tradition to Seattle. Handmade in small batches with a focus on quality, these confections have stood the test of time and are still sought-after today. European-style chocolate creations range from traditional flavored ganache-filled truffles to modern, flavor-infused confections. The chocolates pictured are from Boehm's Candies and Chocolates, which was founded by Austrian Julius Boehm in 1942.

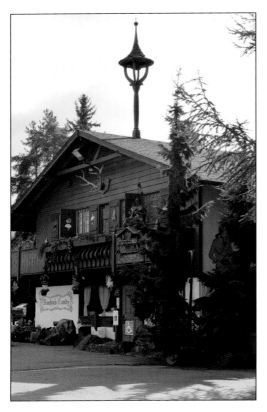

Boehm's Candies & Chocolates, Since 1942. The founder of Boehm's Candies, Julius R. Boehm (1897–1981), left Austria in 1940. He opened his first candy kitchen in 1942 on Ravenna Avenue in Seattle, and in 1956, he moved his company to rural Issaquah, Washington. He commissioned Walter Schefer, from Appenzell, Switzerland, to design and build his Edelweiss Chalet, a chocolate factory and traditional Swiss home. A replica of a 12th-century chapel (from St. Moritz, Switzerland) was added in 1978.

Boehm's Legacy Continues. This traditional European Advent calendar features the happy chocolate family at Boehm's. Current owner Bernd Garbusjuk stands at the chalet door with his chocolates as his son Tyson and daughter Narissa are packing boxes into the red car. Julius Boehm (lower left) walks his famous St. Bernard dog with a friend. Julius's daughter Erika is waving from a car. Bernd's late wife, Joanna, holds a heart, and salesgirls stand on the balcony.

BERND GARBUSJUK, OWNER OF BOEHM'S. Garbusjuk immigrated to the United States in the 1960s and started working at Boehm's Candy Factory in the early 1970s. He started out as Julius Boehm's apprentice, later becoming general manager, and has been owner of Boehm's Candies since 1981. His son Tyson and daughter Narissa will be the second generation of Garbusjuks to lead the company.

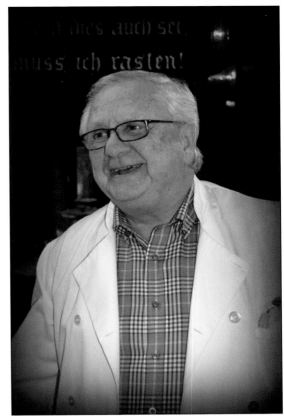

SALZBURG CONNECTION. Bernd Garbusjuk's grandparents owned the famous pastry shop Konditorei Fürst on Brodgasse 13 in Salzburg, Austria. Paul Fürst, a great-uncle of Bernd Garbusjuk, created the original Salzburger Mozartkugel. Only Konditorei Fürst sells the original Salzburger Mozartkugel (in its distinct silver-and-blue foil wrapping). Boehm's rendition of the Mozartkugel is a hazelnut confection made with a marzipan center and double-dipped in dark or milk chocolate.

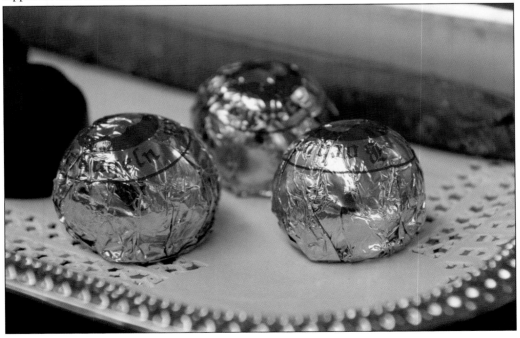

NOBLE AND HANDMADE. At Boehm's, owner Bernd Garbusjuk and his loyal staff continue handcrafting confections and hand-dipping truffles, cooking caramel in copper pots, and producing molded chocolate designs. One-third of Boehm's confections feature European flavors, one-third feature American favorites, and one-third showcase newly evolving chocolate combinations with uncommon ingredients such as ginger, hibiscus, or chili-pepper strings. Pictured below are samples of the "Rovereto Rounds" with, from right to left, ginger, hibiscus, and chili pepper strings; the above photograph features chocolate with almonds.

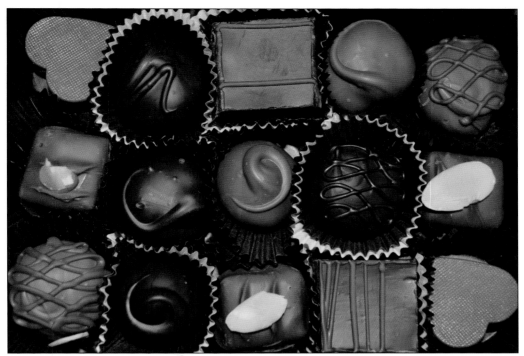

BOEHM'S SIGNATURE. Boehm's handmade truffles were featured on the posters for *Chocolate: The Exhibition*, a traveling exhibit developed by the Field Museum in Chicago. The exhibit explains the history of chocolate and the creation of chocolate from bean to bar. In 2014, the show made a stop at the Seattle Museum of History and Industry.

BOEHM'S SELF-GUIDED WALKING TOUR. As guests stroll past the candy kitchen windows, they may notice the wide variety of chocolate molds used at Boehm's and admire creative displays with subjects ranging from small coins to holiday confections such as 30-pound chocolate turkeys, a wide variety of Santa Clauses, and even this elaborately detailed, horse-drawn rococo carriage!

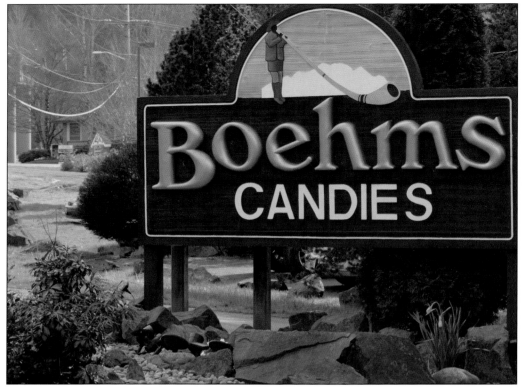

CHOCOLATE, WINE, & ALL THAT JAZZ FESTIVAL. In a continuation of Julius Boehm's civic involvement and generous spirit, Bernd Garbusjuk is an active member of his community and the city of Issaquah. This festival, held each year on the Boehm's Candies grounds, hosts around 400 people and features local food, wine, and jazz.

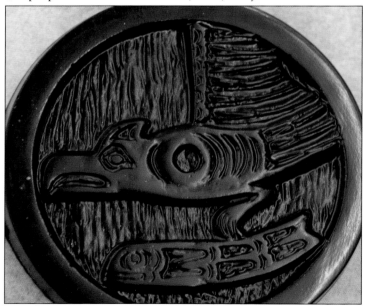

COAST SALISH WHORL ART. Bernd Garbusjuk and local artist Joseph Illig, from CrabCat Studio, united to create chocolate whorls. This whorl features Thunderbird and Orca, a beautiful Coast Salish Native American legend. At Boehm's, more than one local legend has been deliciously rendered in chocolate.

DILETTANTE CHOCOLATES, A SEATTLE LANDMARK SINCE 1976. Third-generation grand chocolatier Dana Davenport propelled local culinary fame into national acclaim with Dilettante Chocolates, which he founded in 1976. Ten years later, a *Newsweek* article called Dilettante "The Best Chocolate in the World." Famous family chocolate recipes go back to a time when royal tastes ruled the European noble palate from Budapest and Paris to the Habsburgs in Vienna and the Romanovs in St. Petersburg—their sweet demands were answered by Davenport's ancestors.

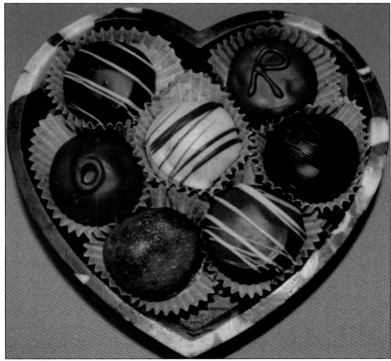

CREATED BY DANA DAVENPORT. Although it has been under new ownership since 2006, Dilettante still honors tradition. A perfect "eat-your-heart-out" gift box is filled with Davenport's hand-dipped grand truffles, including a praline white chocolate truffle, a champagne truffle Romanov in milk chocolate, a l'orange dark chocolate, an amaretto milk chocolate, and Ephemere in dark chocolate.

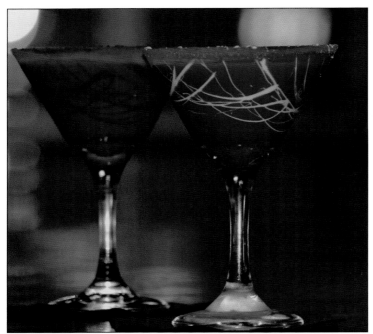

THE EPHEMERE MARTINI. Dilettante's Mocha Café and Chocolate Martini Bar on Broadway offers 20 different varieties of martinis. Half of them are made with chocolate melted right behind the bar. Pictured are the white chocolate martini and the dark chocolate martini, both made with Ephemere truffle sauce and vodka.

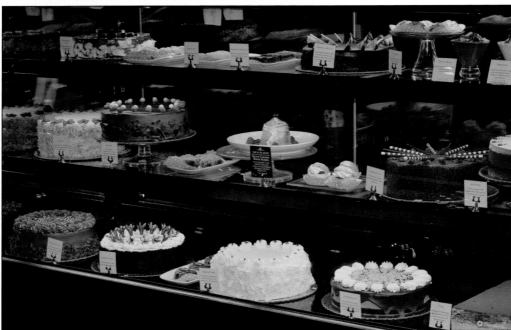

DILETTANTE MOCHA CAFÉ. Chocolate enthusiasts can find the historic location—one of seven—just two blocks north of the original café. The decor is reminiscent of European coffeehouses, an elegant surrounding in which to savor cakes and coffee, inspiring romance and the occasional marriage proposal. The café's signature torte, Rigo Jancsi, is made with chocolate mousse layered between chocolate genoise, raspberry preserves, and a truffle glaze topping. Exquisite truffles round out the chocolate menu.

DILETTANTE'S "MOCHA MENU."
The Dilettante Mocha Café offers mochas and hot chocolates made from five varieties of cacao percentages ranging from 72-percent (extra dark) chocolate from the Ivory Coast and Colombia to 41-percent (milk) chocolate and 31-percent (white) chocolate. The chocolate is melted to order and blended with milk or Dilettante's specialty roast coffee. Founder Dana Davenport was the first person to use the famous Italian La Marzocco espresso machine in Seattle.

DECADENT ICED BEVERAGES.
The bourbon toffee malt is made with salted caramel ice cream, malted milk, Dilettante Ephemere truffle sauce, Jim Beam bourbon, vanilla whipped cream, and Dilettante butter-pecan toffee pieces—pure bliss on Broadway!

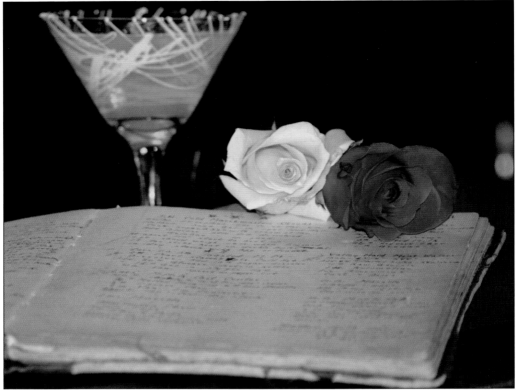

CULINARY CRAFTSMAN DANA DAVENPORT'S RECIPE BOOKS. Davenport began learning the intricate craft of chocolate-making in his early childhood. The storied family recipe books preserve the family's culinary adventures from previous centuries. Famed locations, fanciful ingredients, regional kitchen tools, measurements, and personal remarks are written in ink onto the now fragile and worn pages. This historical treasure is an extraordinary volume of culinary history.

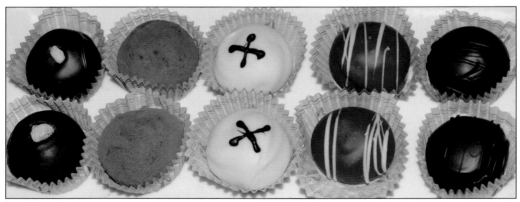

TRUFFLE WITH A NAME. The Madame X Truffle was inspired by Dana Davenport's favorite flavors and by Lana Turner in the movie *Madame X*. French playwright Alexandre Bisson's drama *Madame X* tells the story of a woman who tries to use absinthe to heal her broken heart. Davenport's white chocolate ganache truffle with undertones of caramel and anise made a big impression when it debuted and continues to be a popular choice at Pacific Northwest Ballet's member galas.

THE RHEINGOLD BUTTER PECAN TOFFEE. Commissioned by the Pacific Northwest Wagner Festival, this toffee (in the center of the photograph) was Dana Davenport's contribution to the 1981 performance of Wagner's *The Ring* in Seattle. Dilettante's butter toffee is 50 percent butter, resulting in an utmostly delicate brittle with hints of burnt sugar. The flavor is balanced with sweet butter, cream, and pecan oil. Brunhilde always liked it in milk chocolate, Siegfried in dark, and Kriemhild in white.

DILETTANTE INDULGES CONNOISSEURS. For Dilettante's Mocha Cafés, Dana Davenport envisioned the idea of eating chocolates on the premises. From chocolate boxes to bags of chocolate—why would anyone carry them home? The name "Dilettante," executed in beautiful art nouveau script, elicits feelings of joy by doing what one loves to do and enjoying the creative side of life via chocolate!

FRAN'S CHOCOLATES, UNCOMPROMISING QUALITY. Fran Bigelow is the genius behind Fran's Chocolates, a company she started in 1982 and now runs with her daughter Andrina and son Dylan. It all started with tasting fine chocolate in Paris. While she was living in Berkeley with her family during the 1970s food movement, Bigelow became inspired by French chef Josephine Araldo, and in 1976, she studied pastry-making at the California Culinary Academy under a Swiss pastry chef. With a new appreciation for culinary traditions, ingredients, and taste, she opened her first shop on Madison Street in Seattle in 1982. At Fran's Patisserie and Chocolate Specialties, she wanted to bring to Seattle what she experienced in France—"those perfect moments of bliss that only the finest desserts and chocolate can provide." She "vowed never to compromise on quality and flavor, a principle that still guides me today." According to renowned Seattle chef Tom Douglas, she is the beloved "Queen of Chocolate."

FRAN'S HIGH EXPECTATIONS FOR QUALITY. Local, sustainable materials are used throughout all four of the Fran's Chocolates boutiques inspired by modern European and Asian design and architecture. The newest location, in the historic Georgetown neighborhood, is in the Seattle Brewing and Malting Co. building, a proud space bringing back a solidity and breadth of vision from earlier generations. Built in 1901, the beautifully restored building had been unoccupied for decades when Fran's decided to use it as its new headquarters. Polished original tile, exposed brick walls, original Carnegie steel stairs and pillars, and modern furnishings create a perfect balance of old industrial aesthetic and modern design. It houses a retail shop that serves chocolate and espresso beverages, a tasting room, and an area where visitors can view the production facilities.

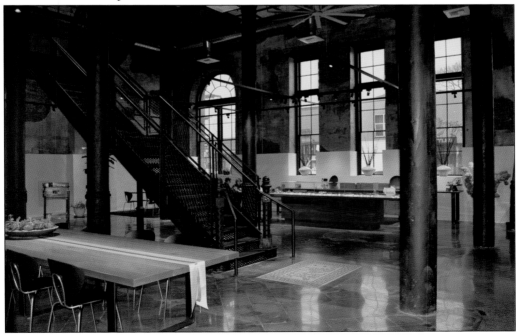

SEA SALT CARAMEL. In 1985, Fran's Chocolates introduced a soft, slow-cooked classic caramel. Inspired by Michael Chiarello in Napa Valley, who used sea salts to enhance the flavor of his foods, she started experimenting with French artisan sea salt in caramels in 1998. "I started infusing salt in the caramels, then I decided to garnish the top of the dark chocolate caramels with a pinch of the grey sea salt crystals. I found that the sea salt created a dramatic new and exciting taste. It opened up and extended all the flavors in the caramel and chocolate. I was pleased that my customers also responded to this new combination, which now is our most popular product." These caramels, favorites of Pres. Barack Obama and First Lady Michelle Obama, are given as gifts to visitors at the Oval Office.

THE COMPLEX FLAVOR OF FINE CHOCOLATE. Fran Bigelow ensures that all of her products "have the complex flavor of fine chocolate as the primary taste sensation." The Pure Dark is the original truffle that started her chocolate line. "My loyal customers at the beginning were people who had experienced chocolates at the best shops in Europe and were thrilled to find something comparable in Seattle," Bigelow muses. "The best thing about working with fine chocolate is how you are constantly discovering new and exciting ways to bring out subtle new flavors." The Chocolate Imperial (above) has a rich, soft, dark chocolate center dipped in Fran's 64-percent blend of dark chocolate and sprinkled with cacao nibs. The 64-percent Fran's Blend dark chocolate is her version of perfection in chocolate, a taste shared by her loyal customers across the world.

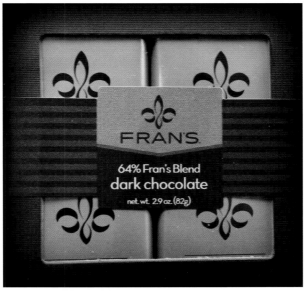

A Taste Sensation Like No Other. In addition to pure chocolate truffles, Fran's Chocolates offers a wide variety of chocolates accented with nuts, teas, fruits, espresso, and whiskey. "Other ingredients are used as a complement to the chocolate and are used to highlight distinct flavor notes and create a new appreciation for chocolate," says Fran Bigelow, who hand-selects these ingredients—chocolate from the finest cacao beans, cream from Organic Valley, hazelnuts from the Willamette Valley, peppermint from the Yakima Valley, Madagascar vanilla, McCarthy's Oregon single malt whiskey, and coffee from Seattle's Caffé Vita, among others. A seasonal favorite, eagerly anticipated each fall and winter, is Fran's double chocolate fig (above), a whole Calimyrna fig filled with dark chocolate ganache and dipped in dark chocolate; it combines the unique flavor and texture of dried figs with the smoothness of fine dark chocolate.

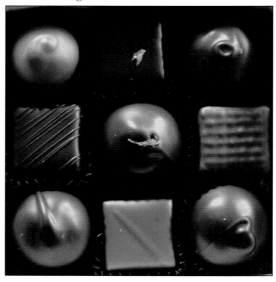

FRAN'S CELEBRATION OF FINE CHOCOLATE. Fran Bigelow's philosophy is to "offer an extraordinary experience for the customer in the quality of the product, the beauty of the packaging, and the celebration of fine chocolate atmosphere of Fran's chocolate shops." Every purchase can be enhanced with a beautiful box hand-tied with a coordinating ribbon. The elegant "Thousand-Flower Keepsake Bowls" and numerous specialty boxes, like a hand-stitched leather keepsake box, can be filled with Fran's chocolates and confections. Each season has its color, and in spring, Fran's exquisite paper boxes dazzle the eye with the fresh green of the season. Throughout the year, various boxes and ribbons are available in seasonal colors such as red at Christmas and fuchsia for Mother's Day. University of Washington favors shine in purple and gold, and the YWCA gift "box of inspiration" features a bronze-colored box with fuchsia ribbon.

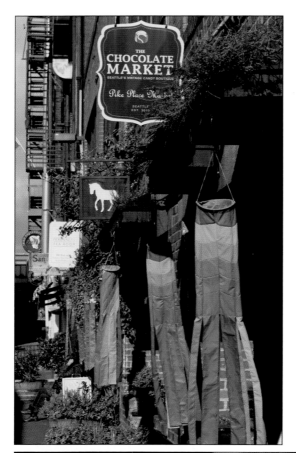

GOSANKO TRUFFLES AND MOLDS, SINCE 1987. Gosanko, the company that runs the Chocolate Market at Pike Place Market, has been a leading producer of solid molded chocolates since 1987, continuing the tradition of sculpting and manufacturing chocolate molds. Ronnie Roberts' company produces foil-wrapped solid molded chocolates, including tulips and carrots for Easter; turkeys, grape clusters, and Halloween bats in the fall; and Santas on sticks, snowflakes, and snowmen for Christmas, to name a few. Specialties of the Pacific Northwest include solid chocolate Coho salmon and fighting trout. Shiny and colorful oversized raindrops make Seattle's rainy days a lot happier. The local Seahawks football team is celebrated with bright blue-and-green foil–wrapped footballs.

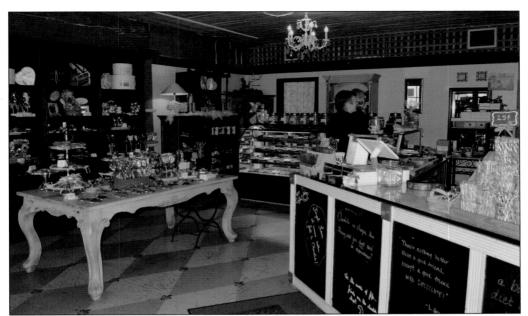

GOSANKO'S CHOCOLATE MARKET. The Old World–style candy store in Seattle's famous Pike Place Market is a warm and friendly shop where customers—as well as employees—are happy. Happy employees and happy customers are just what owner Ronnie Roberts strives for every day. His mission is to create "a chocolate experience people love." Advertising is done only through word of mouth and pleased customers. At Gosanko, each chocolate piece is hand-rubbed and hand-wrapped after the molding process, resulting in a highly detailed chocolate confection. Along with producing over 10,000 molds, Gosanko also creates chocolate logos and signage for local businesses.

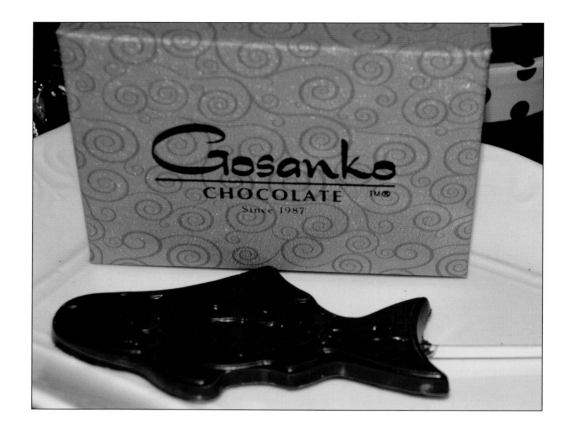

GOSANKO MANUFACTURING FACILITIES AND HEADQUARTERS IN AUBURN, WASHINGTON. Along with the Pike Place Market Shop, Gosanko chocolates are sold at the factory store and at the Outlet Collection in Auburn. Owner Ronnie Roberts and his team also make a wide variety of truffles and caramels by hand. Roberts married into the Gosanko chocolate business and is a self-taught chocolatier who creates the company's full line of truffles. His specialties are very-berry truffles and liquor confections that use spirits such as Fireball whiskey, rum, Irish cream, Kahlua, limoncello, and crème de menthe.

Three

CHOCOLATIERS WITH SHOPS

NEXT WAVE OF CHOCOLATIERS. The city and region, with its long and delicious chocolate history, is thrilled and fortunate to have the tradition continue with the next wave of chocolatiers. Often seasonal and local, the vast variety of chocolate offerings—which come from businesses ranging from small-batch chocolatiers to large-scale operations—is unique and creative. This picture features a colorful display at Brugge Chocolates.

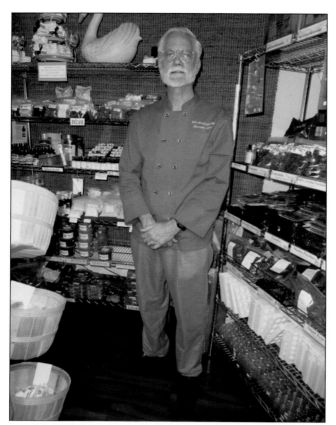

"CHOCOLATE MAN" BILL FREDERICKS. Bill Fredericks (left) is known in the Seattle area as the "Chocolate Man." With degrees in both chemistry and geology, he has a scientific understanding of chocolate and its properties. He is the successful owner of Chocolate Man, a chocolate supply business and teaching kitchen in Lake Forest Park. Fredericks and his team also make a wide assortment of various truffles, caramels, barks, bars, and molded novelties sold on site. Pictured below are his bright and flavorful blood orange truffles. He has taught chocolate-making in culinary programs at local colleges, training a new generation of local chocolatiers. For those who cannot make it to a class, Fredericks produces DVDs like *Dare to Cook Chocolate*. An internationally trained chocolate chef, Fredericks is also involved in organizing Seattle's annual Northwest Chocolate Festival.

CHOCOLATE MAN SHOP IN LAKE FOREST PARK. Bill Fredericks' shop is a mecca for chocolate lovers and beginning chocolatiers. Fredericks supplies high-end tools and machines for purchase and rent and also sells exquisite chocolate products. Home cooks and bakers can visit Chocolate Man to acquire hard-to-find chocolate-making supplies, including candy molds imported from Belgium, cups, foils, boxes, quality flavoring oils, tools, transfer sheets, vanilla beans, cocoa butter, chocolate shells, fair trade chocolate, and assorted chocolate varieties and couvertures. In the on-site candy kitchen, Fredericks teaches hands-on classes—students not only leave with a huge box of chocolates but also with a wealth of knowledge about the origins of chocolate, tempering, and all there is to know about working with chocolate.

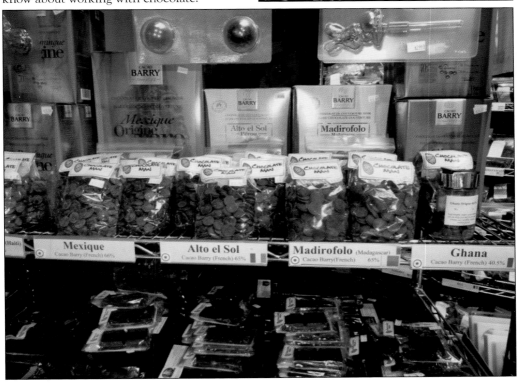

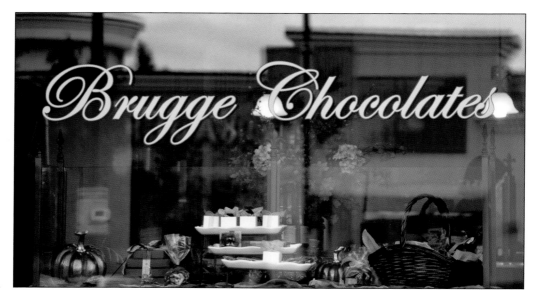

OLD-WORLD CHARM AT BRUGGE CHOCOLATES. Susan Walukiewicz, owner of Brugge Chocolates, opened the first artisan chocolate boutique in Redmond. Brugge Chocolates is a dream come true for Walukiewicz, who opened the store in 2010 after she retired from Microsoft. She trained at the Barry Callebaut Chocolate Academy in Chicago and, through her travels in Europe, was inspired to outfit her chocolate shop with beautiful dark woods, traditional wrought-iron details like fleur-de-lis finials, Italian white Carrara marble countertops, and fine tapestries. She named her store after her favorite European city—Brugge, Belgium. In addition to shopping for truffles and other confections, customers can pair purchases with fine port and table linens.

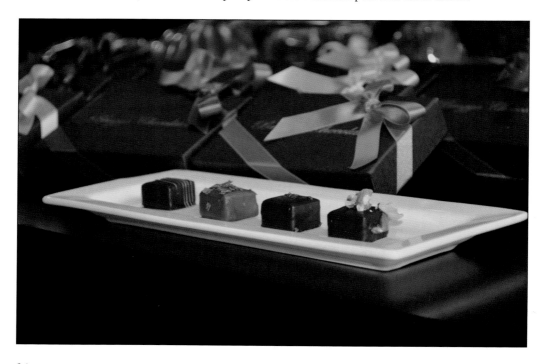

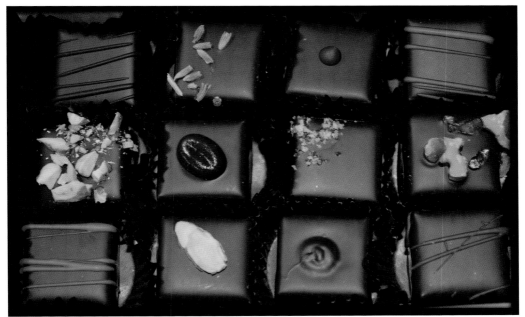

TRUFFLES WITH FRUIT CENTERS. At Brugge Chocolates, owner Susan Walukiewicz's love of Alaskan fruit jellies was the inspiration to create truffles such as black raspberry, strawberry balsamic, or bananas foster—a delicious layering of banana puree, vanilla bean, and rum enrobed in white chocolate. Brugge also sells chocolate-dipped candied ginger, lemon and orange peel, gorgeous glacé apricots, oranges dipped in chocolate, and colorful pâté de fruit made of imported French fruit purees. Walukiewicz is attuned to the needs of her loyal customers and appreciates their suggestions and feedback. She will often first try new flavors in her on-site kitchen; one was the Cherry Jubilee, a morello cherry puree infused with *kirschschnaps* and covered in milk chocolate—another customer favorite.

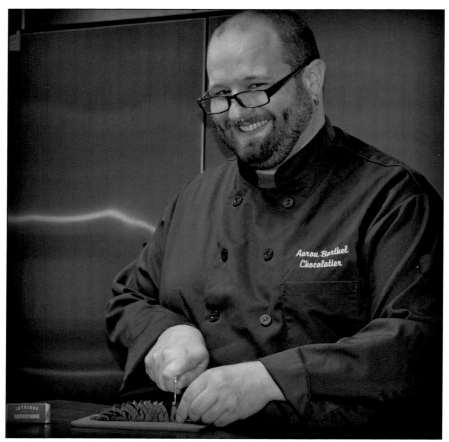

INTRIGUE CHOCOLATE CO. Dairy farm boy, botanist, brewer, and baker Aaron Barthel ultimately discovered the possibilities within chocolate, saying he "was struck by the revelation that the simplest possible technique could be used to elevate and expose the flavors that surround us." A purist, he reverently infuses every ganache with the secrets of nature. Barthel also understands the anatomy of human taste buds. Using pure, seasonal, and locally sourced ingredients, he coaxes flavor out of herbs, seeds, roots, leaves, spices, and spirits, then saturates high-quality chocolate with the essences of their flavors. The results are "intriguing," and in 2006, Barthel and his friend Karl Mueller established Intrigue Chocolate Co.

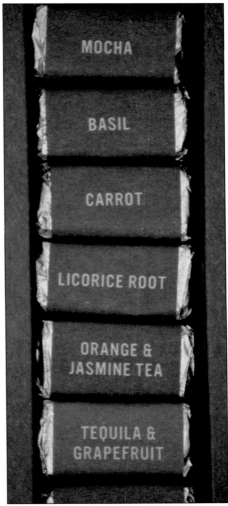

EVERY FLAVOR TELLS A STORY. Visitors to Intrigue Chocolate Co., located in Pioneer Square, are enlightened with an talk by co-owner Aaron Barthel on the human anatomy of taste and then invited to sample a flight of truffles: cubes of ganache lightly dusted with cocoa powder. Intrigue offers 12 rotating flavors as mixed truffle sets or individual truffle bars. A truffle bar—Barthel's genius invention—is a log of pure ganache that can be cut to taste and paired with wine, spirits, coffee, or cheese or eaten as is—a perfect dessert! By joining the "truffle of the month" club, patrons can effortlessly enjoy Intrigue truffles year-round. From rather tame flavors like rum, vanilla, honey, and chili to more daring concoctions featuring bay leaf, licorice root, or porcini mushroom, an intriguing adventure awaits.

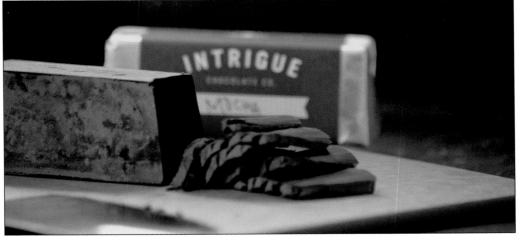

VAVAKO. Celebrating the diversity of Bellevue, Nicolas Espinoza is proud of his elegant truffles. He and his business partner, David Morales Vela, took over Amore Chocolates in 2013 and founded Vavako. The Ecuadorian *babaco* plant is their inspiration for the company name: it is the most cold-tolerant plant in its family—a good omen for their endeavor. Espinoza and Vela, who is from Ecuador, have personal connections with their cocoa farmers and know the origins of their cocoa beans. Customers can choose from an array of handmade truffles plus wines and champagne that complement the taste of each chocolate. Vavako makes single-origin chocolate bars—customers can savor them by slowly allowing the chocolate to melt on the tongue to experience each taste sensation.

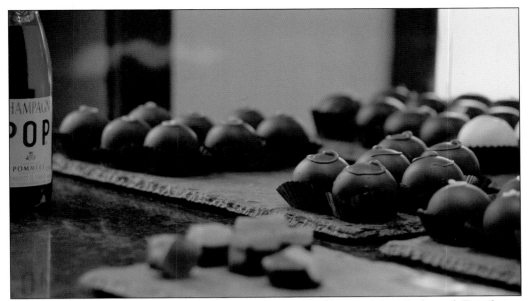

ECUADORIAN CHOCOLATE SPECIALTIES. Artfully decorated and lusciously enrobed in rich Ecuadorian chocolate, these truffles pique customers' taste buds. Displayed on cool, grey slate tiles, the chocolates are kept at just the right temperature.

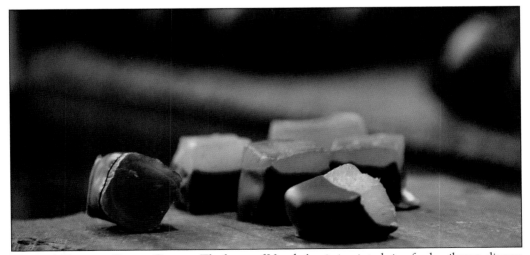

VAVAKO'S ELEGANT DIPPED GINGER. The heart of Vavako's mission is to bring fresh, vibrant, diverse flavors and chocolates to the Seattle area. Vavako truffles, beautifully displayed and packaged, add to the chic flair of Bellevue's old Main Street and beyond. Evocative shapes and colors truly enhance the rich depths of Ecuadorian chocolate.

SEATTLE CHOCOLATES, WHERE "CHOCOLATE DELIVERS HAPPINESS." In 2003, Jean Thompson took over Seattle Chocolates after working at Microsoft. Under her leadership, Seattle Chocolates became a nationally-certified Women's Business Enterprise. Thompson's expertise is marketing, and there is no other chocolate company in Seattle that markets specifically to women. The headquarters and factory store in Tukwila, south of Seattle, welcomes customers with a fuchsia pink door, pink walls, and mannequins in pink dresses created by Bri Seeley, an inspirational women's fashion designer. Coco Chanel's couture legacy is the inspiration for Jcoco, a new line in the so-called "American couture chocolate" category created by Jean Thompson—the "J" in Jcoco—and her team. This new line is shaped by global tastes and influences in a way similar to haute couture fashion; it features creative combinations such as Black Fig Pistachio, Edamame Sea Salt, and Peanut Strawberry Baobab, to name a few.

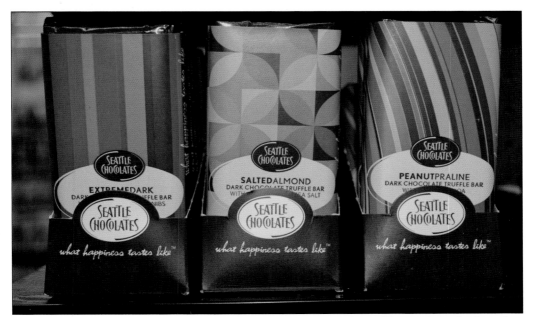

SEATTLE CHOCOLATES MANIFESTO. Offering numerous smooth truffles made with chocolate sourced from Rainforest Alliance Certified farms using non-GMO ingredients, the company is proud of its innovative flavor inclusions. With the sale of every chocolate bar and truffle, Seattle Chocolates make a point to give back to the community. The company's manifesto sums it up: "We believe in surrounding yourself with things you love. We believe in licking the spoon. We believe in colorful moments and daydreams. We believe that looks DO matter. We believe a little bit of indulgence every day is the way to go. We believe that chocolate helps people live in the moment. We believe laughter is life's best accessory—makes you sexy and goes with every single thing in your closet. We believe that chocolate can make a difference in our hungry world."

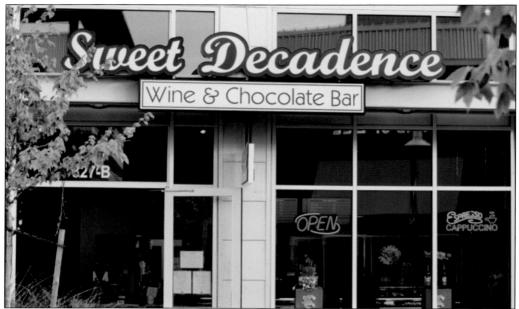

SWEET DECADENCE WINE AND CHOCOLATE BAR. Sandra Wixon is a woman of many talents—as a bartender, baker, and chocolatier, she has many tales to tell! Her biggest passion is chocolate, and it all started when she created her own wedding treats, which, many years later, led her to open a café and chocolate shop in Newcastle. After seven years there, she reinvented her business and combined coffee, wine, and chocolate at Sweet Decadence Wine and Chocolate Bar at the Boeing Landing shopping mall. Tempting aromas of fresh coffee (by local roaster Herkimer Coffee) and warm chocolate fill the air. The café's floor is painted to resemble poured milk chocolate swirls, and chocolate-hued drapes flutter in the cooling wind of the ceiling fan. All chocolates are handmade in the on-site kitchen. (Both photographs by Valverde Images.)

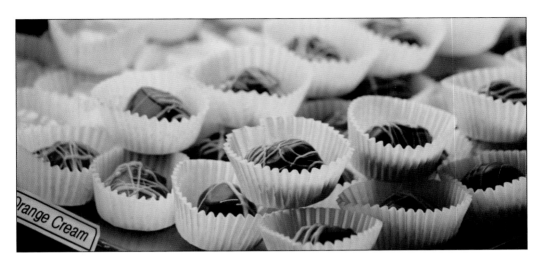

SWEET DECADENCE MIXOLOGY. Sweet Decadence owner Sandra Wixon delights in creating original truffles such as Team M.I.N.T. (with a nod to the home team), a smooth crème de menthe truffle with a peppermint burst. According to Wixon, it's an "excellent finish to a satisfying meal . . . or Super Bowl win." Her signature creation, Jo Cool, a peanut butter truffle, is both creamy and crunchy—a lady's truffle. The popular Baconator—a chocolate-covered confection with real bacon pieces—satisfies a man's palate and is nicknamed "The Man Truffle." Another Sweet Decadence specialty is the "chocolate wine bottle"; Wixon dips an unopened bottle of wine in a liquid chocolate paired to match, and after the chocolate cools, the customer who purchases the "chocolate wine bottle" pulls a string attached to either side of the bottle, breaking open the chocolate shell in order to savor it with the wine. (Both photographs by Valverde Images.)

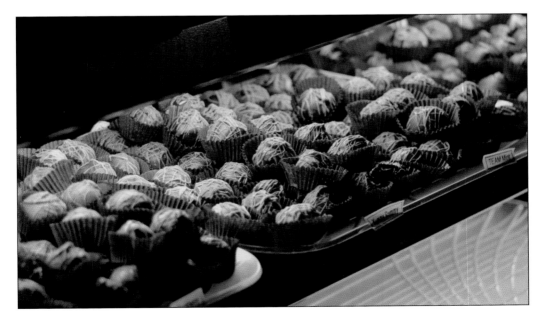

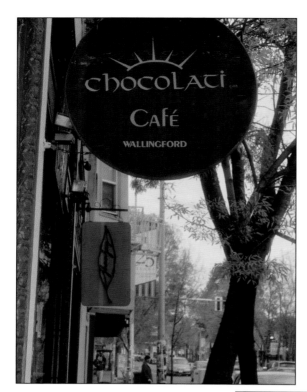

CHOCOLATI. Christian Wong, founder of Chocolati, designed the logo himself: a gilded rising sun in the shape of a crown inspired by ancient Mayans and royalty. Handmade chocolates, truffles, molded chocolates, chocolate-dipped fortune cookies, hot chocolate, and espresso drinks await those who visit. A family member suggested to Wong that he explore the boutique chocolate business, and he was in the right place at the right time.

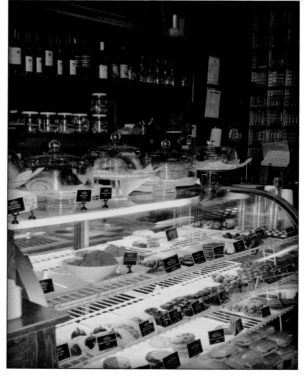

MAKING THE DREAM COME TRUE. With a business degree and IT experience, Chocolati owner Christian Wong soon realized his dream of self-employment. The Sutliff Candy Company—a household name in Seattle since 1938—had closed its doors, and in 2000, Wong acquired its machinery. Later, he added specialized custom chocolate molds. These purchases enabled Wong to begin his business and produce chocolates in an ever-increasing variety.

CHOCOLATI IS LOCAL.
Seattleites love their neighborhoods! Christian Wong, a genuine Seattleite and owner of Chocolati, knows his neighborhood. His concept includes cozy cafés that are laid-back hangouts for locals that feature original art on the walls. He operates three neighborhood cafés—in Wallingford, Greenlake, and Greenwood—selling coffee drinks, chocolates, and drinking chocolate, along with a few bakery items. The cafés and a downtown kiosk location at the Seattle Public Library provide Wong with a strong local base from which to develop collaborations all over Seattle. Wong's latest business endeavor is an expansion into functional chocolate. He produced a raspberry chocolate bar and truffles for Nutraberry.

CHOCOLATI'S SIGNATURES. Chocolati owner Christian Wong's espresso truffle is made with Martin Henry coffee from Puyallup, Washington. The marionberry truffle incorporates Oregon marionberry puree with dark chocolate. Chocolati offers signature truffles, a changing line of specialty flavors, and truffles based on customer suggestions and feedback. Customers may be tempted by, among many others, the ginger wasabi truffle, a 62-percent dark chocolate confection made with crystallized ginger bits. Sunshine in Seattle uses dried mango from the Philippines dipped in dark chocolate. A molded chocolate fish, aptly called Fish n' Chips, features potato chips mixed with milk chocolate, offering tasters an exceptionally sweet and salty treat. Pictured above are, from left to right, Sea Salt Caramel, Espresso Mint Dome, and Strawberries N' Cream truffles; pictured at left are Ginger Wasabi truffles.

Four

CHOCOLATIERS IN SHOPS

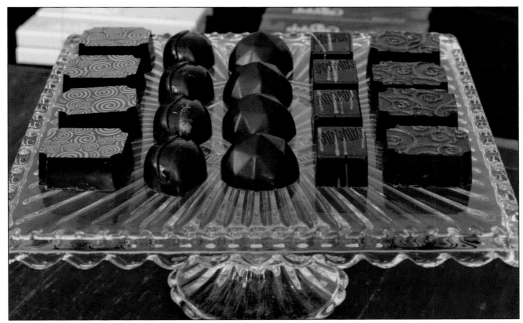

TALENTED, CREATIVE, AND BUSY. The chocolatiers featured in this chapter do not have brick-and-mortar stores; instead, they sell a wide variety of exceptional chocolates, truffles, bars, and chocolate confections online. Some of the featured chocolates are also available in local specialty shops, cafés, and farmer's markets. These chocolates are by Dolcetta Artisan Sweets.

YUKON JACKSON'S: FROM WEST SEATTLE WITH LOVE. Born in West Seattle's Alki neighborhood, Keith Jackson made Seattle headlines even before he could speak. As a baby, he was pulled unharmed from the debris of the legendary Alki Landslide of 1951. The land literally claimed Jackson as a true West Seattleite. He graduated from West Seattle High School, got married in West Seattle, travelled to Alaska working as the chef for the fishermen on crab boats, then returned home to Seattle. He has been a well-known presence on the Seattle chocolate scene since 1990. A pastry chef by trade, he graduated from the Culinary Arts Program at Seattle Community College and specializes in artisanal chocolate creations.

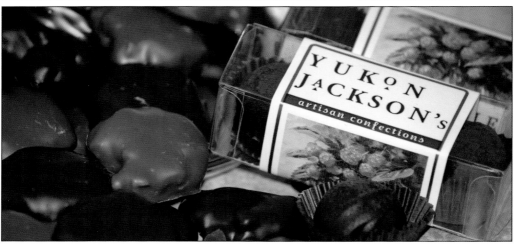

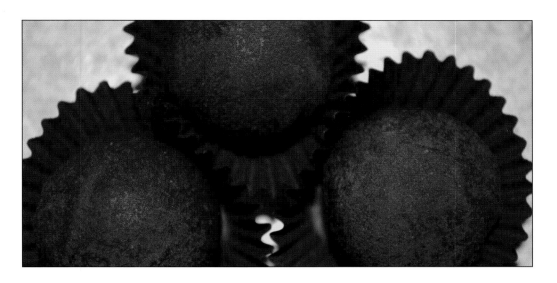

THE FRAMBELLE RASPBERRY TRUFFLE STORY. Keith Jackson's signature piece is the lovely cocoa-dusted raspberry confection pictured above. The raspberry ganache is infused with a dessert wine produced by Bainbridge Island Perennial Vintners using raspberries from Akio Suyematsu's neighboring farm, which has been in operation since 1928. There is a lot of history at the "corner of bitter and sweet," and this delicious truffle bursts with fresh raspberry flavor—not too bitter, not too sweet. Caramel and pecan turtles enrobed in 60-percent Belgian or milk chocolate are another favorite. Jackson fondly refers to them on the packaging as a "Herd of Turtles." His cakes are legendary as well. At a West Seattle fundraiser, for instance, his Frambelle chocolate torte sold for $700. Find Yukon Jackson's chocolates at the Husky Deli, Metropolitan Market, and Thriftway in West Seattle, among other locations.

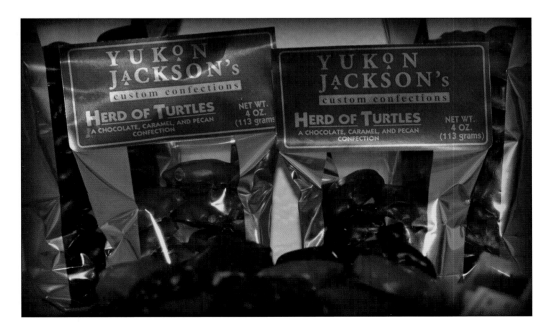

LESLEY'S GOURMET. Lesley's Gourmet owner Lesley Clapham happily exclaims: "Chocolate is love!" Clapham is quite philosophical about chocolate, saying "it's all about love and sharing." This is how she views the world. Born in South Africa, she eventually moved to Seattle, where her paternal grandfather was born. As a child, she heard him tell wonderful stories of the Emerald City. She credits her maternal Lebanese grandmother with instilling in her a passion for food and exotic flavors. "Food is fun! Food is life," she says, with a radiant smile that reflects her warm, welcoming, and generous hospitality.

FINE ARTISAN CHOCOLATES. In the tradition of artisanal craftsmanship, Lesley's Gourmet chocolate reflects a deep respect for people and traditions and an understanding of the balance of life. Owner Lesley Clapham invites her customers to enjoy each of her handmade specialties as much as she enjoys creating them.

50

LESLEY CLAPHAM AND MICHEL CLUIZEL. Clapham began her professional life as a schoolteacher. After moving to Seattle, she followed her passion for food, opening a high-end bakery and catering business. In 1996, she introduced her own chocolate line and proceeded to focus solely on the chocolate business. Her dedication to the highest quality of products led her to Michel Cluizel's chocolate from Normandy, France, which offers a perfect balance of deep notes and full-bodied smoothness. This exquisite chocolate complements the layered flavors of the confections at Lesley's Gourmet: traditional cocoa-rolled truffles, classic truffles, caramel buttercups, and salted caramels. Chocolate nut confections and nutritious fruit and nut bars made with dried fruits, tree nuts, and a hint of caramel round out the Lesley's Gourmet collection. Above is a close-up of three of her chocolate-covered caramels featuring a sampling of salts—rainbow peppercorn salt, lavender salt, and Sri Lanka curry salt.

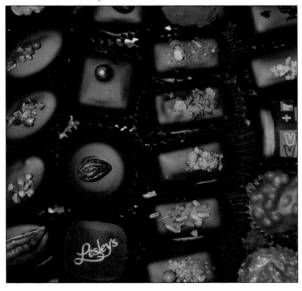

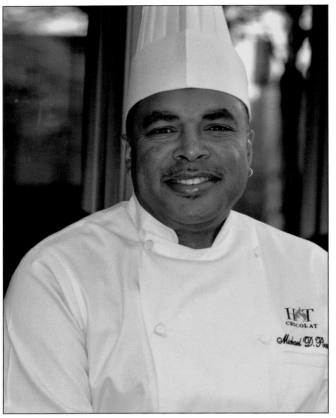

HOT CHOCOLAT ARTISANAL CHOCOLATE CREATIONS. Hot Chocolat (formerly MDP Signature Chocolates) is a fitting name for chocolatier and chef Michael D. Poole, a Paris-trained master. Poole radiates a love for life, spice, and making people happy through food; he learned to cook from his grandmother. In addition to gaining 30 years of experience as the firehouse chef for the Seattle Fire Department, he made his dream come true and graduated from Le Cordon Bleu in Paris. *Et bien sur,* he speaks French. As a lieutenant with the fire department, he is in control of stressful situations; as a chocolatier, he is in control of the many intricate nuances of working with chocolate. Hot Chocolat's perfect balance of spice and chocolate will set hearts on fire.

FRENCH RECIPES AND TECHNIQUES. With impeccable taste in chocolate, Hot Chocolat owner Michael Poole brings European flavors to Seattle. After many summers as an apprentice in France, in 2014, Poole made his debut as a master chocolatier at Mococha, a small chocolate boutique in Paris. He taught a master class on blending his signature spice, cayenne pepper, with chocolate. Spicy truffles are an unusual combination to the French palate. He also makes caramel truffles with habanero and the so-called "firehouse" chili. Among his favorite milder flavors, his signature confection—a heart-shaped truffle with dark raspberry ganache enrobed in white chocolate and dipped in yellow and orange at the heart's wings—stands out. Poole teaches chocolate classes in West Seattle and has taught at the Seasons of My Heart cooking school in Oaxaca, Mexico.

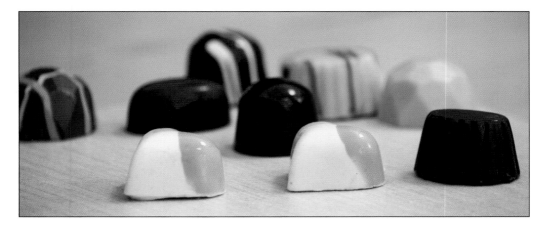

WELLINGTON CHOCOLATES, WOODINVILLE'S SECRET. Julie Berg makes an array of one-of-a-kind truffles and chocolate confections in her chocolate kitchen tucked away in a lovely garden in Woodinville, the heart of Seattle's wine-tasting region. A self-taught chocolatier with over 30 years of experience, Berg graduated from the Ecole Chocolat in 2007. She is dedicated to experimenting and creating new flavor combinations, and her imagination is limitless! She says, "I have truly found my passion."

WELLINGTON CHOCOLATES HONEY TRUFFLE. The visually stunning honey truffle, decorated with a gold bee-and-flower print, features a milk chocolate honey ganache with a delightful layer of wildflower honey from Duvall, molded in dark chocolate. The Fiori di Sicilia is made of dark Belgian chocolate with notes of citrus flowers and vanilla. Berg's signature truffle is a passion fruit truffle with a hint of cayenne pepper.

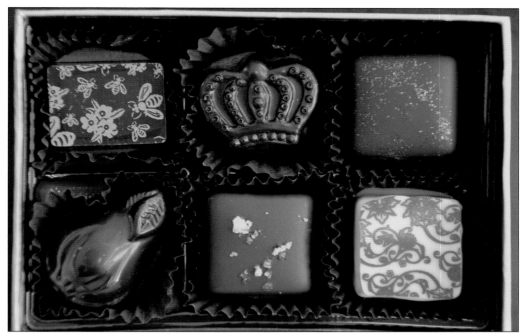

CHOCOLATE AND WINE. Wellington Chocolates owner Julie Berg's truffles have enriched the wine-tasting industry in Woodinville, offering exquisite complements to locally produced wines. Berg is a hands-on chocolatier. Berg sources as many ingredients locally as possible. She grinds lavender buds from Woodinville Lavender for her lavender chocolate bars. She picks raspberries in nearby Carnation for her raspberry puree and cooks down pears and their juice for her beautiful pear truffle—the classic Poire Hélène, reinvented! In fall, she features Grandma Lilian's Pumpkin Pie Truffle made with pumpkin puree and a hint of coconut. She uses honey from Val's Surroundings, in Duvall, for her jasmine flower truffle and coffee from Quest Coffee, in Bothell. She also creates beautifully molded chocolates and signature bars artfully wrapped in paper envelopes and tied with a bow.

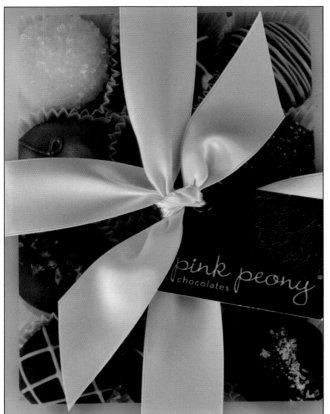

PINK PEONY CHOCOLATES.
In their chocolate kitchen in Poulsbo, Washington, Mary Kay Johncock and her chocolate partner Linda Darley create gorgeous truffles. Pink peonies are Johncock's favorite flowers, and the delicate blossoms are the inspiration for Pink Peony Chocolates. Life took Johncock from North Dakota to Bainbridge Island, a short ferry ride west of downtown Seattle, where she met Darley. Self-taught chocolatiers since 2005, they are proud of their small-batch chocolate company. Johncock always liked to cook and figure out recipes; working with chocolate challenged her in new and exciting ways. She weighs, rolls, and dips each truffle by hand, and they have the "snap" and silky-smooth texture of masterfully tempered chocolate. Each is decorated with meticulous attention to detail.

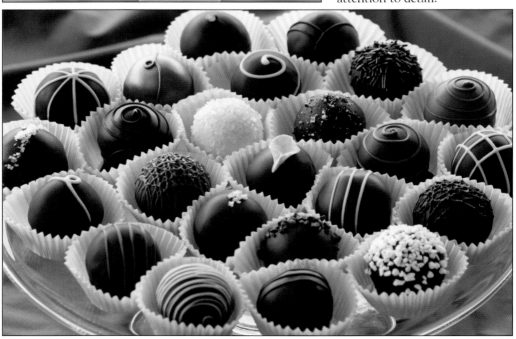

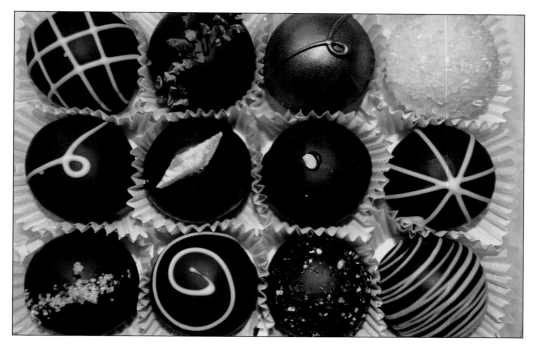

A FEAST FOR THE EYES. In 2005, Mary Kay Johncock's dark chocolate caramel with sea salt was so popular that she continued to develop flavors and started Pink Peony Chocolates with her friend Linda Darley. They make about 24 different truffles using only local heavy cream—not butter. The truffles are made with 65-percent Colombian couverture and dipped in 54-percent chocolate. One can taste the fresh lemon juice and freshly grated lemon zest in the lemon truffle. The mint truffle combines organic peppermint, mint tea, and a bit of pure peppermint oil. The cherry truffle blends morello cherry puree and dried sour cherries. The tartness of pomegranate is wonderfully balanced by the creaminess of white chocolate in their stunning pomegranate truffle, made with pomegranate and white ganache, enrobed in white chocolate, and topped with sparkling sugar.

TREVANI TRUFFLES. "Chocolate is food, not candy," says chocolatier Annie Boyington. She was encouraged by her children to finally sell her truffles to the public, and they came up with the wonderfully Italian-sounding name "Trevani," which is a combination of their family's names: Annie, her son Troy, and her daughter Eva. Annie (left) and Eva are pictured at left. Since 2007, Annie, a self-taught chocolatier, has been selling truffles, bars, and bonbons at local farmer's markets, where she established connections with farmers and local artisans.

FARMER'S MARKET FRESH. Trevani Truffles owner Annie Boyington now sources nearly all of her ingredients locally—except chocolate, of course! She uses fresh dairy cream from Sea Breeze Farm on Vashon Island, Seattle Urban Honey, Enumclaw Honey, berry wines from Rockridge Orchards, and sheep's milk, fresh cheese, and yogurt from Glendale Shepherds on Whidbey Island. The cake truffle with sheep's milk yogurt is a delicate, slightly unexpected, and refreshing chocolate confection.

"Bombon" for Truffles. Trevani Truffles owner Annie Boyington uses dark Venezuelan chocolate—hence the use of "bombon," which is Spanish for "bonbon" or "truffle"—and dark Ecuadorian, Mexican, and organic Dominican Republic chocolate. The minty Mojito Truffle, topped with a green candied mint leaf, features dark chocolate ganache infused with rum and fresh wild mint from her garden, and it is stunningly refreshing. The dark Oscuro is dipped and sprinkled with cocoa nibs. C4—chocolate cherry cheesecake topped with a Red Hot—is made with Glendale Shepherds' fresh sheep's-milk cheese. Everything is made fresh and should be eaten right away. Trevani's loyal customers eagerly anticipate market day, when they can grab a "bombon" treat.

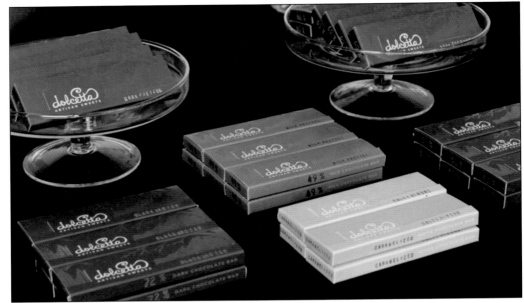

DOLCETTA ARTISAN SWEETS. Andrea Terrenzio has a degree in landscape architecture but turned to making pastry for a more creative and less competitive outlet. While working in Bhutan at an exclusive resort kitchen, she was exposed to a whole new world of flavor, ingredients, and culture. As a pastry chef in fine Seattle restaurants, she began to explore chocolate. From chocolate bars and caramels to bonbons, truffles, and pâtés de fruit, her creations are exquisite and beautifully packaged. The packaging of her chocolate bars and caramels depicts scenes from the Pacific Northwest, showing off her myriad creative skills.

MORSELS MELT IN YOUR MOUTH. The truffles created by Andrea Terrenzio for Dolcetta Artisan Sweets are made in the French tradition—ganache squares coated in cocoa powder. Truffle flavors range from hazelnut, which incorporates roasted hazelnuts and hazelnut liqueur, to salted caramel and peanut crisp. Bonbons come in flavors such as dark ginger, passion fruit, and vanilla bean. Her nearly translucent sugar-dusted pâté de fruit come in morello cherry, apricot, pear, and passion fruit—*bravissimo*! For her caramels, she uses just the basics: cream, butter, honey, and vanilla. Terrenzio wants people to treat themselves to something delicious, but she also gives back, and 10 percent of Dolcetta's sales go to help feed people in need. The packaging on her chocolate bar proclaims: "Joy is all around us: snowy peaks at sunrise, birds fluttering, flowers blooming, delightful surprises, and sweet little things like this handmade chocolate bar. At Dolcetta, sweetness counts!"

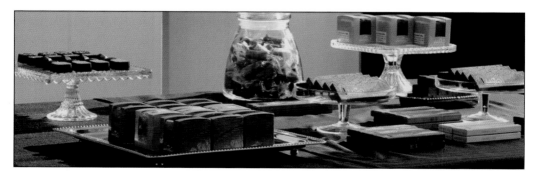

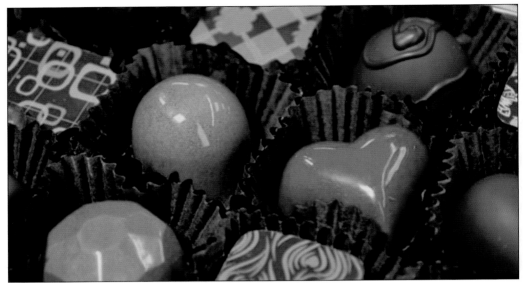

BLUE STREAK CHOCOLATES. In Snoqualmie, at the foothills of the Cascade Mountains, is the home of Blue Streak Chocolates. Mary Kelley creates chocolate truffles, chocolate fruit bars, caramels, and gourmet chocolate caramel popcorn in small batches. Originally from Maine, Kelley has been a baker and chocolatier for 30 years. Blue Streak's salted caramels—her best sellers—come in many flavors ranging from classic salted caramel to chocolate espresso, piña colada, champagne, and the summery raspberry lemonade, among others. Her specialty bars are brimming with delectable dried fruits, nuts, and seeds.

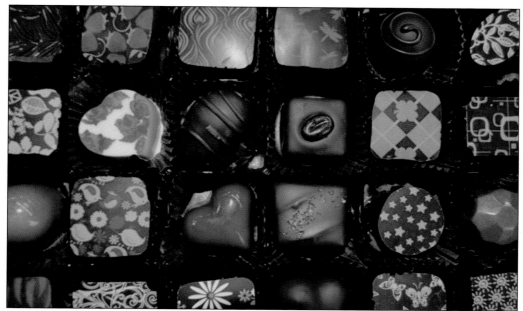

COLORFUL BLUE STREAK. Using a blend of soy-free chocolates from manufacturers in the United States, Belgium, and Germany, Blue Streak Chocolates owner Mary Kelley's handmade treats incorporate local raw honey, herbs from her garden, local dairy products, and homemade fruit purees. Her creative flavors include pumpkin spice truffle, coconut lime (a summer specialty), and lovely honey lavender truffles. The French Kiss truffle, a caramel chocolate infused with cognac, and Caribbean Passion, a combination of pineapple and coconut with exotic rums, are among her countless flavors. Kelley encourages her customers to come up with flavors, and she will make custom blends for them.

KELLY'S CHOCOLATES. Kelly Mero graduated from college with a degree in psychology, and after some soul-searching, she decided to study under world champion chef Ewald Notter at the Notter School of Pastry Arts in Orlando, Florida. She quickly realized her fascination with sculpting chocolate, and back home in Seattle, she started to specialize in truffles. Mero's main focus is not only to create intense flavors, she also wants her chocolates to be a feast for the eyes. Vibrant colors reflect the flavor of each truffle. Passion fruit shines in red and yellow, maple pecan in fall colors, and raspberry in a deep red. Kelly's Chocolates are available online, and in Seattle, shoppers can find her special collection for Market Spice at Pike Place Market, where her truffles are infused with the flavors of the Market Spice specialty teas.

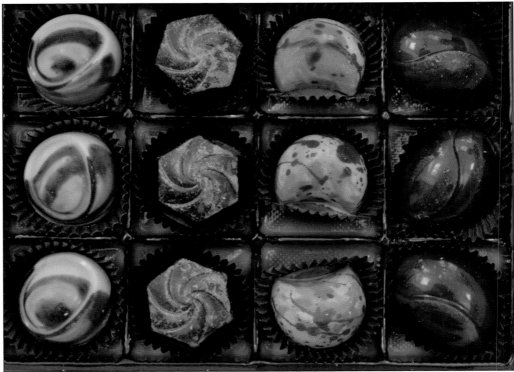

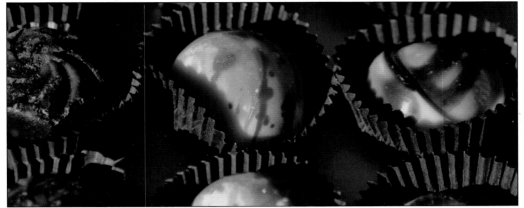

COLOR SPLASH, SWIPE, OR SWIRL. Each of Kelly Mero's truffles has her artistic signature. She uses Swiss chocolate, local cream, and fresh fruit purees for her Kelly's Chocolates creations. Mero makes custom chocolates for events such as the Museum of Flight Campaign or a *Downton Abbey* event at Seattle's public television station. The Boeing Truffle, created for the local airplane manufacturer, is a layered truffle featuring homemade caramel and dark chocolate espresso ganache encased in white chocolate.

"SOUTHERN DANDY." Kelly Mero's creation is a Georgia dream confection. This chocolate has a Southern twist, featuring candied pecans, buttery caramel made with Tahitian vanilla beans, and dark chocolate, and it is dusted with gold powder. Mero crafted this gem especially for her husband, who has Southern roots; it is her signature truffle.

SOULEVER CHOCOLATES. Aimee Morrow uses only whole, unprocessed ingredients—primarily organic and seasonal, when possible, and locally sourced. In her childhood kitchen, everything was made from scratch, so it is only natural that Morrow would make chocolates that way, too. A self-taught chocolatier guided by holistic principles, she is thrilled by the savory aspect of cooking with flavor and chocolate. Every ingredient is conscientiously selected to create wholesome chocolates.

HEALTH-CONSCIOUS CHOCOLATE. Soulever Chocolates are for everyone, especially for those with dietary restrictions, on a low glycemic or paleo diet, or with sensitivities to dairy, soy, and/or wheat. Morrow creates pure foods without fillers or preservatives. Her newest endeavor is to create chocolates that include crickets, a trendy source for low-impact protein, and to incorporate more medicinal ingredients, such as maca, damiana, or kava kava.

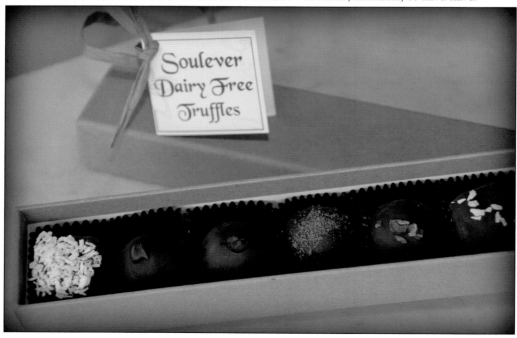

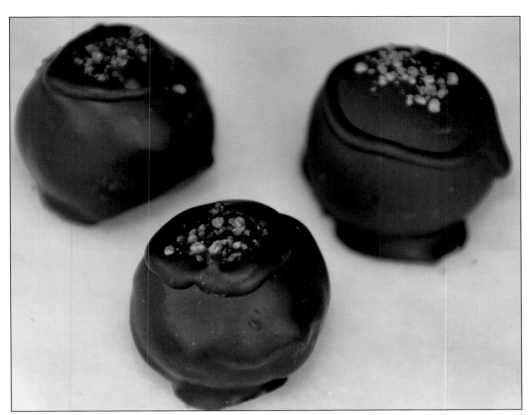

SOULEVER'S SWEET AND SAVORY COMBINATIONS. Soulever Chocolates owner Aimee Morrow uses local sea salt to balance sweetness in the chocolates and raw honey from Naches, Washington. In place of sugar, she uses organic, raw coconut nectar and raw honey, and she replaces dairy with a combination of coconut oil and cocoa butter. The cocoa butter, cocoa liquor, and cocoa powder she uses are sourced from Peru, where cocoa beans are grown organically. She incorporates spices and herbs to create unusual flavors such as sage and olive oil or Mexican mocha, which delivers a kick with the addition of smoked serrano chili. Soulever's summer flavors include cherry hazelnut nib and kaffir lime and coconut cream. Her signature flavors—Peruvian dark chocolates and Mexican mocha—are available year-round.

WOW CHOCOLATES. Lesly Chacon (right) received her culinary training in Caracas, Venezuela, worked for many years in hotel catering on Margaritas Island, and now runs WOW Chocolates with her sister Maire (left). Maire Chacon, a master with paintbrush and color, was an art teacher at a Spanish school; she also leads art workshops for children at Seattle Children's Hospital. Vivid colors, unusual shapes, and unique flavors are the hallmarks of handcrafted WOW Chocolates. Single-sourced Venezuelan chocolate and organic vegetable dyes, tropical flavors, spices, rum, and coffee combine with the sisters' culture, zest for life, and tradition. Colorful bonbons made with tamarind and chile de árbol or pineapple cardamom not only excite the palate but also entice the eye. Chocolate can dance to the music of flavor!

COLORFUL BONBONS. Each bonbon and molded piece from WOW Chocolates is hand-painted—a one-of-a-kind, artistic chocolate creation. The company receives commissions from local businesses to produce extraordinary chocolate sculptures, such as shells and sea creatures for the Seattle Aquarium and wild shoe designs for events in the Neiman Marcus shoe department. South American color, music, flavor, and celebration are part of the inspired treats created by sisters Lesly and Maire Chacon. As the Chacon sisters say: "WOW Chocolates will captivate your senses and take you on an extraordinary journey through our world of delightful, exotic and colorful bonbons. Our passion for these delectable delicacies is infectious and is reflected in every bite."

SASQUATCH CHOCOLATE COMPANY. Sue Foster changed the name of her company from Big Foot Chocolate Company to Sasquatch Chocolate Company in 2013. A self-taught chocolatier, Foster started out with couverture, and she now tempers her own chocolate. To produce the Sasquatch balls, she uses her own panning machine. Her chocolates come in flavors ranging from milk to dark chocolate layered with caramel and sometimes Himalayan pink salt or ghost pepper salt and almonds, along with others like coconut, banana, and coffee. Her signature chocolate balls are foil-wrapped by hand and color-coded according to flavor.

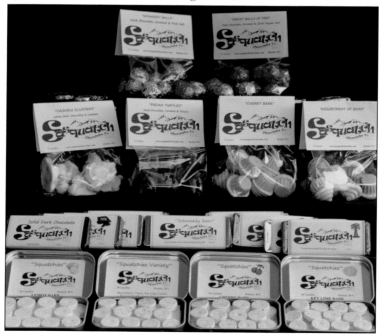

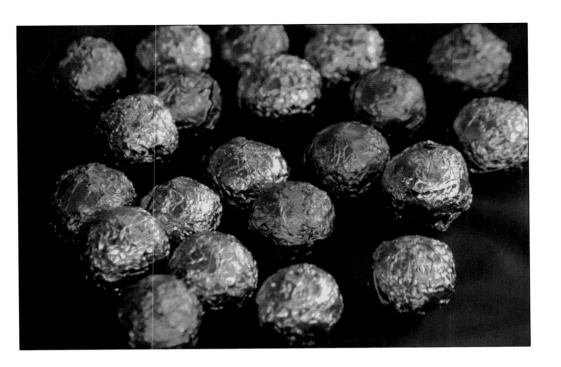

SASQUATCH CHOCOLATE COMPANY IN THE PACIFIC NORTHWEST. Sue Foster started selling her chocolates at local bazaars, fairs, and fundraisers, and now her treats can be found in bed-and-breakfasts and local shops all around Puget Sound. She also makes wedding favors and chocolate bars with personalized wrappers. Cashew clusters, pecan turtles, chocolate "sasquatch feet," and colorful chocolate mini-cupcakes are also popular items. Sasquatch's newest additions are "Squatchies," small, flavored chocolate disks packed in cute rectangular tins. With these portable treats, customers can treat themselves to a refreshing chocolate anytime.

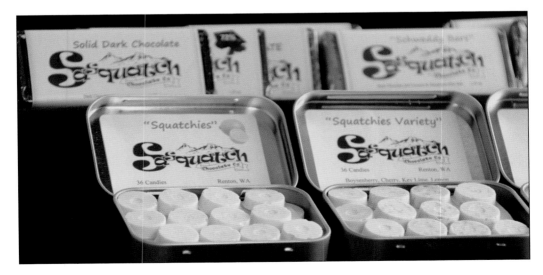

SELEUŠS CHOCOLATES.
Alexander Long is a connoisseur of high-quality chocolate. Formerly in the defense industry, he now devotes his time and energy to making truffles. Alexander Long wants to conquer the world with different means than Alexander the Great, who used fire and swords. There are Olympic heights in Long's chocolate, and the name of his company, Seleuš, which began in 2014, was inspired by the Greek king Celeus and the Elysian Mysteries. A self-trained chocolatier and scientist, Long experimented with different chocolates and ingredients before perfecting his first line of truffles. He studies cacao content and calculates to exacting standards, creating blueprints and flavor diagrams to produce his line of expensive truffles.

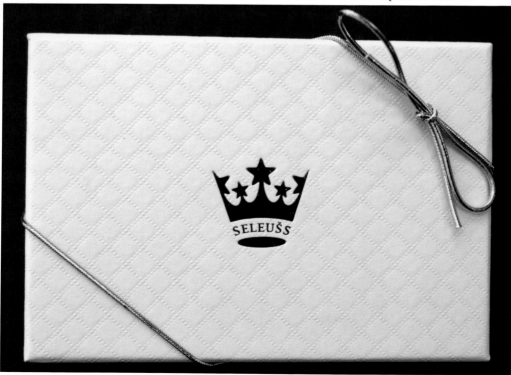

MICRO-BATCH TRUFFLES. Alexander Long, owner of Seleuš Chocolates, frequents farmer's markets during his global travels. Inspired by flowers, herbs, and spices, he creates flavors such as hibiscus and violet and lavender honey, which uses three different varieties of lavender. His "international" truffles incorporate ingredients sourced from around the globe, including the Greek Rose Truffle, with rose petals from Greece and a crystallized rose petal from France. Each limited-quantity Seleuš truffle collection includes hand-numbered, gold-sealed cards listing ingredients and wine or spirit pairings. The Orange Blossom Honey truffle pairs beautifully with champagne, while the Greek Rose Truffle complements a crisp rosé. Long also incorporates alcohol into his truffles—his "Boozy Collection" features triple sec, raspberry brandy, Caribbean rum, French brandy, and kirsch; another collection uses coffees and matcha green tea.

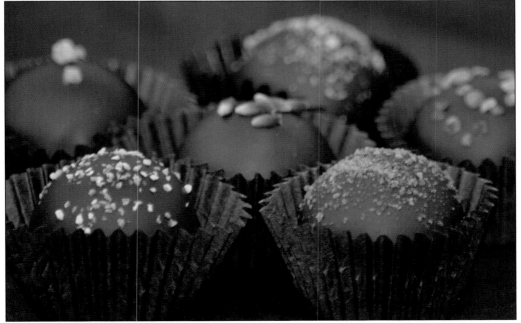

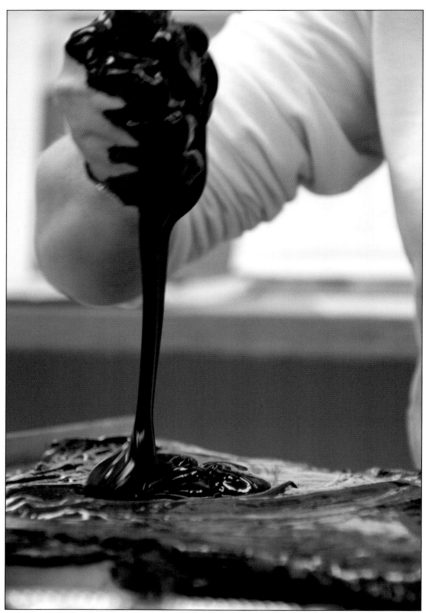

CHOCOLATE TOURS, CLASSES, AND RUNS. Seattle's chocolate community is comprehensive. The Chocolate Indulgence Walking Tour (www.savorseattletours.com) focuses on enjoying chocolate in all of its delicious forms—from bars to cupcakes to ice cream. Boehm's Candies Store and Chalet Tour offers a self-guided tour of the candy kitchen and of Julius Boehm's authentic Swiss chalet. Theo Chocolate's factory tour presents information about cocoa-growing and chocolate-making and includes chocolate samples; it goes through the factory and the on-site kitchen and ends in the shop. Chocolate classes are offered at Boehm's (pictured), Chocolate Box, Chocolate Man, Chocolopolis, Hot Chocolat, Intrigue, Oh! Chocolate, and Theo. Chocolate enthusiasts can even participate in Mud and Chocolate trail races (www.mudandchocolate.com) that end in a chocolate feast or run the Hot Chocolate Seattle 15K/5K race (www.hotchocolate15k.com).

Five

BEAN-TO-BAR
CHOCOLATE MAKERS

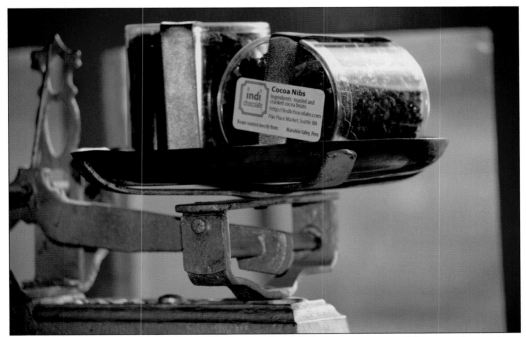

BEAN TO BAR. Direct trade from cacao farms, where beans are grown and harvested, to where the chocolate is made paves the way for more ethical, sustainable production in an industry overshadowed by a history of exploitation. Personal business relationships and fair payments directly impact farmers and their growing, drying, and fermentation methods. Pictured here are cocoa nibs from indi Chocolate.

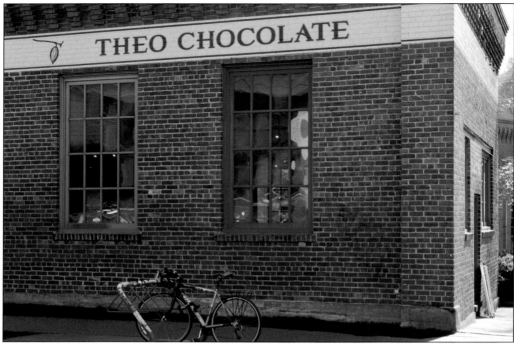

THEO CHOCOLATE, BEAN-TO-BAR PIONEER. In 2004, Joe Whinney and Debra Music moved from the East Coast to Seattle. Since 1994, Whinney had been pioneering the supply of organic cocoa beans into the United States. Moving to Seattle was a leap of faith: the city had a reputation for being receptive to innovation, having a thriving outdoor culture and an international vibe, being less materialistic and more conscientious about making decisions, and supporting an informed food culture. In short, Seattle was the place to launch a company that centered on ethically sourced chocolate. In March 2006, Whinney's dream came to life at the company's Fremont headquarters with Theo's inaugural run of organic chocolate—the first made in the United States. The name "Theo" comes from *Theobroma cacao*, the botanical name for the cacao tree.

THEO'S COCOA BEANS. After cocoa beans are harvested, fermented, and dried in their country of origin, they go through Theo's destoner, which cleans the exterior of the cocoa beans. The cleaned beans go into the vintage 1960s German ball roaster that can roast up to 400 pounds of beans at a time. Roasting brings out the flavor aroma. The roasted beans are broken open in the winnower, and shells are separated from cocoa nibs, which continue into the stone mill and ball mill, where they are turned into cocoa liquor. Cocoa liquor goes through the refining and conching processes before becoming the finished liquid chocolate used to make Theo's special chocolate blends. When Theo Chocolate was founded in 2005, there were few chocolate-makers in the United States, and at the time, no other bean-to-bar company was creating organic, fair trade–certified chocolate products.

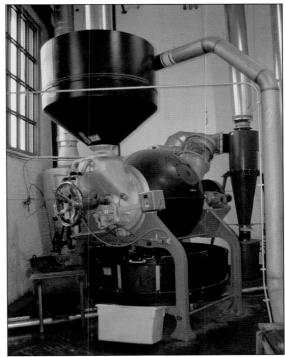

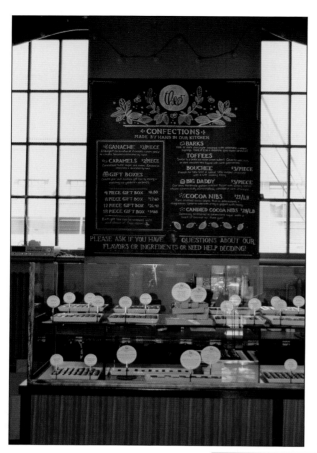

"DOING GOOD WHILE DOING WELL." Leading by example through socially responsible and sustainable business practices, Theo combines ethical cocoa sourcing with a careful manufacturing process. The company believes in enlightened capitalism, as shown through its dedication to treating cocoa farmers more justly. Theo produces all of its chocolates at its factory in Fremont—from truffles to sea salt caramels, chocolate bars, and drinking chocolate. Theo invites the public into the factory for a fun and educational tour, where visitors hear about cocoa sourcing and bean-to-bar manufacturing and are invited to sample various types of chocolate. In the on-site kitchen, skilled chocolatiers create chocolate bars like Burnt Sugar, Lemon, Mint, Noir, Scotch, and Hazelnut *Gianduja*, among others. The tour ends in the factory retail store.

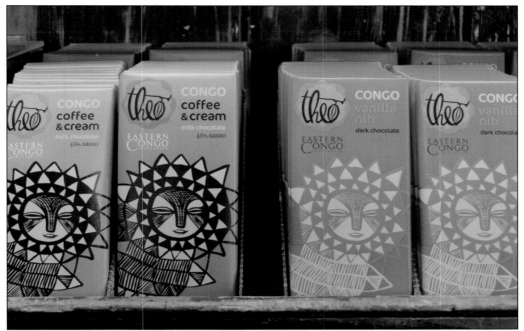

Theo, Pioneer in Flavor Innovation. When Theo's "fantasy bars" hit the market, the public was amazed with the ingredients that can go into chocolate—the Bread and Chocolate bar combines dark chocolate with bits of buttered toast; the Coconut Curry bar is made with 45-percent milk chocolate, toasted coconut, and exotic curry spices. Theo's Classic Bars come in more mainstream flavors. Theo's partnership bars, created in conjunction with Eastern Congo Initiative, are Congo Coffee & Cream and Congo Vanilla Nib. Theo Chocolate, Caffe Vita, and the Eastern Congo Initiative collaborate with Congolese cocoa and coffee farmers to make these chocolate bars. The cocoa, coffee, and vanilla are sourced in Eastern Congo. A portion of the sale of these chocolate bars benefits Eastern Congo Initiative. Theo sources over half of its cocoa from Eastern Congo.

INDI CHOCOLATE: BEAN-TO-BAR, BEAN-TO-BODY. Erin Andrews, owner of indi Chocolate, brings premium cacao to the Pacific Northwest. She makes small-batch artisan chocolate with cacao she sources from around the world by direct trade. She knows the farmers, the beans, the producers, and the roasting process. This close relationship offers an important benefit for both Andrews and the farmers—she says "the best brings out the best." Small-scale coffee roasters already dot the landscape in Seattle, but Andrews is the first to bring small-batch cacao roasting to Seattle. Erin loves the "Meet the Producer" principle of Pike Place Market, so she wanted to be there, among all the other farmers and producers, to sell her chocolate products. She enjoys interacting with customers and local farmers; it's an "artisan market, a collaborative market," she says.

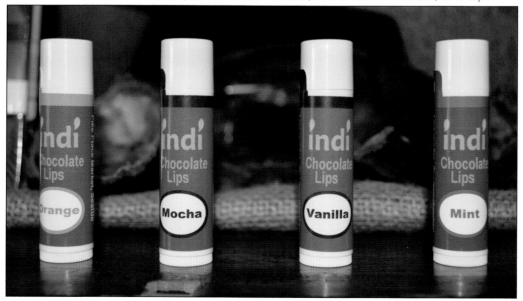

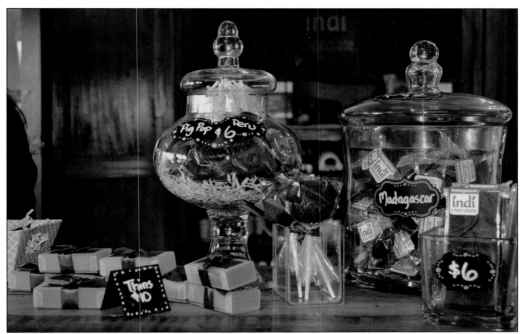

THE PUREST OF PURE. At indi Chocolate, owner Erin Andrews's chocolate selection is deliberate, and the quality is superior. indi's 72-percent dark chocolate has three ingredients—cacao beans, cocoa butter, and sugar—and is free of soy, dairy, and gluten. Andrews wants the great taste of the beans to guide the flavor experience. The fragrant and soothing chocolate chai tea, a comforting blend of spices with hints of chocolate, is also worth a try. For flavorful cooking and grilling, indi makes four different savory spice rubs. indi Chocolate's Body Care line emerged from Andrews' need to provide chemical-free beauty products for her own daughters. Using essential, high-quality ingredients, she has created wonderfully scented chocolate mint and chocolate orange body lotions, along with five different lip balms.

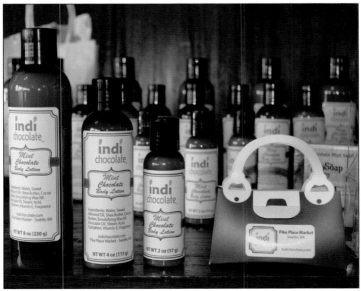

HOT CHOCOLATE. Chocolat Vitale's offering is pictured here. Head to the following shops for a warm and comforting cup of delicious hot chocolate:

Café Presse, 1117 Twelfth Avenue, Seattle, 98122 (206) 709-7674
Chocolat Vitale, 6257 Third Avenue NW, Seattle, 98107 (206) 297-0863
Chocolate Box, 106 Pine Street, Seattle, 98101 (206) 443-3900
Chocolati, 1716 North Forty-Fifth Street, Seattle, 98103 (206) 633-7765 (and other locations)
Chocolopolis, 1527 Queen Anne Avenue North, Seattle, 98109 (206) 282-0776
Dilettante, 538 Broadway East, Seattle, 98102 (206) 329-6463 (and other locations)
Fran's, 5900 Airport Way South, Seattle, 98108 (206) 682-0168 (and other locations)
Hot Cakes, 5427 Ballard Avenue NW, Seattle, 98107 (206) 453-3792
Kakao, 415 Westlake Avenue North, Seattle, 98109 (206) 833-5467
Le Pichet, 1933 First Avenue, Seattle, 98101 (206) 256-1499
Sweet Decadence, 827 North Tenth Place Suite B, Renton, 98057 (425) 572-6572
Theo, 3400 Phinney Avenue North, Seattle, 98103 (206) 632-5100
Vavako, 10149 Main Street, Bellevue, 98004 (425) 453-4553

Six

CHOCOLATE SPECIALTY SHOPS

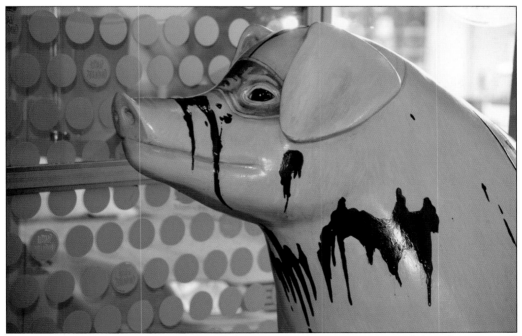

CHOCOLATE SPECIALTY SHOPS. Seattle and the region are home to exceptional chocolatiers as well as exceptionally well-stocked chocolate specialty shops that carry not only local chocolates and confections but also delicious chocolates and truffles from around the country and the globe. When Seattle's Pike Place Market Foundation organized the Pigs on Parade fundraiser, the Chocolate Box sponsored this pig covered in chocolate; her new home is at Seattle Chocolates' headquarters.

CHOCOLATE BOX. Located up the hill from Seattle's famous Pike Place Market, the Chocolate Box, wedged between a cupcake store and a long-standing Seattle souvenir shop, is a lovely escape from busy Pine Street. Customers will find a variety of chocolate, bars, truffles, and bonbons from the Pacific Northwest, along with national and global chocolate varieties. Owner Valerie Brotman and manager Cathy Davila fondly refer to their chocolatiers as "truffletiers," and they are proud to showcase local chocolate and small producers. Everything in the store is hand-picked and chosen for superior quality and taste. A wide variety of wines from Washington and Oregon complements the chocolates.

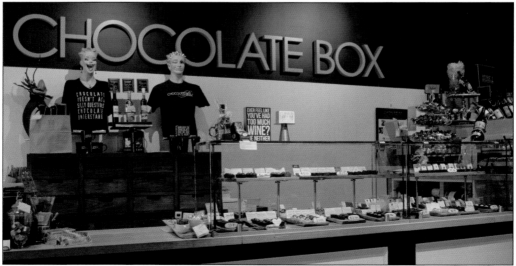

CHOCOLATES AND EVENTS.
According to Chocolate Box owner Valerie Brotman and manager Cathy Davila, "the best chocolate-makers in the world live right here in Seattle; passionate, creative chocolate chefs who have been recognized nationally and internationally by their peers." Enjoy a cup of exquisite drinking chocolate or one of the many hot drinks made with chocolate shavings from Chocolat Vitale. Customize a drink by adding peanut butter, cocoa nibs, salted caramel, or even orange cardamom. Chocolate Box also hosts hands-on events and offers fun and educational classes on wine and chocolate. During March and April, it hosts the Hot Chocolate Festival, serving a different hot chocolate specialty every day.

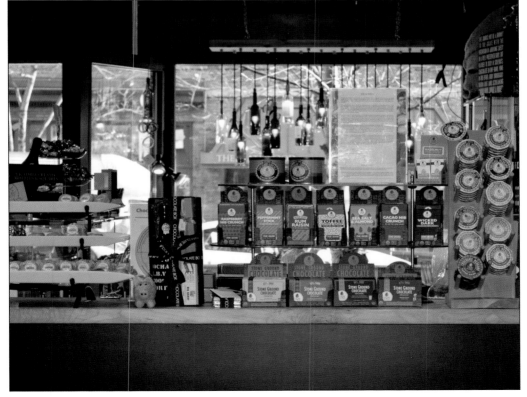

Hot Cakes Molten Chocolate Cakery, Where "Chocolate Is Beautiful." Autumn Martin is a trained chocolatier and former head chocolatier at Seattle's Theo. She embraces chocolate in an intense and sincere way and credits much of her knowledge to her coworkers at Theo and Julian Rose, her mentor at the Callebaut Chocolate Academy in Montreal. At Theo, she invented innovative new flavor profiles that nobody had dreamed of, like the Bread and Chocolate bar, a combination of salt, chocolate, and buttered toast. Martin uses 70-percent Theo chocolate at her Ballard and Capitol Hill shops. Her signature item is the molten chocolate cake in a mason jar served with vanilla ice cream. As a Pacific Northwesterner, she grew up with smoked fish and meats—she tried smoking chocolate, and one can find smoked chocolate chips at Hot Cakes, too!

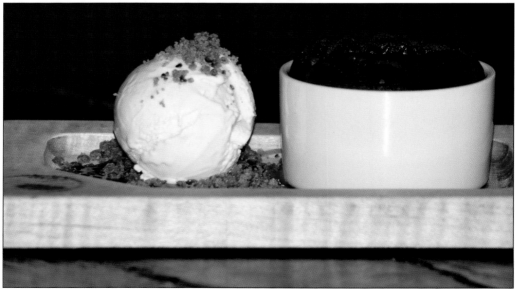

JOY AND ECOLOGY. Through learning about organic farming at Edmonds Community College culinary school and later working on a farm in Spain, Hot Cakes owner Autumn Martin began to care deeply about the cocoa fruit and everything involved in the entire process of growing cacao beans. She feels words like "sustainable" are often overused. As a chef and chocolatier, Autumn finds her own words to express her deep and informed thinking. "It is all about joy and ecology—about growing, nurturing, bringing forth fruit without depleting the soil, and happily eating in season. You can't only take, you have to give back."

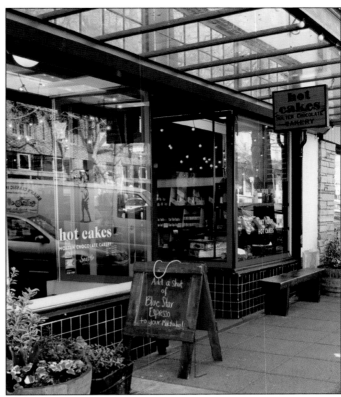

CORNER-STORE VIBE AT CHOCOLAT VITALE. Trained as a painter and printmaker, Janet Eicher is a self-taught chocolate *esperta* who took over the Chocolat Vitale brand in 2010. She then opened a chocolate shop and café in the Phinney neighborhood—Chocolat Vitale, a corner store that offers "something for everyone." Alongside drinking chocolate and espresso drinks, high-end chocolate bars and truffles, patrons may find Chinese carvings, old classroom pull-out maps, pasta and pasta sauces, select teas and spices, and works by local artists. The interior of the brownstone mercantile is an unexpected blend of general store, meeting place, and art and furniture gallery. The beautiful antique cash register perfectly reflects Eicher's eclectic style. Her love of high-end, mid-century modern furniture is showcased throughout the café.

NO COCOA POWDER EVER ADDED. When customers see the Duomo on the beautiful shiny brown bag of rich drinking chocolate, they know that they are in a special place. Initially inspired by the previous owner's Italian grandmother, Angelina Vitale, Chocolat Vitale mixes the spirit of the Italian "mama" who provides only the best for her children with current owner Janet Eicher's childhood memories of an old-fashioned Midwestern corner store. Although visitors to Chocolat Vitale will not find a soda fountain, they can order a cup of velvety drinking chocolate made with molten chocolate. Eicher's specialty is a rich dark Venezuelan drinking chocolate, but she also offers a milder blend of fine Swiss and Belgium drinking chocolates in addition to mixes flavored with raspberry and orange spice. All of Chocolat Vitale's mixes are produced on-site.

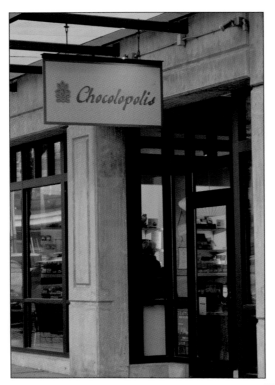

CHOCOLOPOLIS, A WORLD OF CHOCOLATE.
Up the hill from downtown, in Seattle's Upper Queen Anne neighborhood, is Chocolopolis. Visitors can browse more than 200 artisan chocolate bars from 20 countries, truffles made in-house, and a select variety of truffles by other artisan chocolatiers from the United States.

A TASTY WEALTH OF KNOWLEDGE.
Chocolopolis owner and proprietress Lauren Adler is known for her discerning palate and knowledge of flavor nuances in chocolate. She readily shares her wealth of knowledge with customers and takes pride in the education of her staff. Customers can learn much about terroir and the flavor of chocolate, bean-to-bar production, craft chocolate, and micro-batch chocolate. They can also sit down to a steaming cup of hot chocolate. Her seasonal infused drinking chocolate is phenomenal!

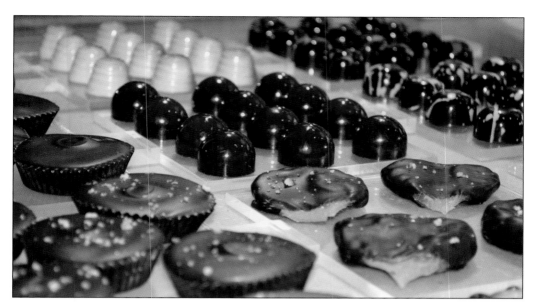

DID YOU KNOW? Lauren Adler, owner of Chocolopolis, knew she wanted a retail specialty store and researched chocolate before opening Chocolopolis. Customers will discover answers to what the term "artisan chocolate" means or what the percentage of chocolate in bars indicates. Adler developed the charts on the walls of her beautifully modern store that tell everything about various chocolate-growing regions, including that Venezuela produces some of the most prized cacao in the world. Chocolopolis carries an extensive array of exquisite products arranged by continent—makers and melters—and selected for their superior quality, ingredients, and, most importantly, for their taste.

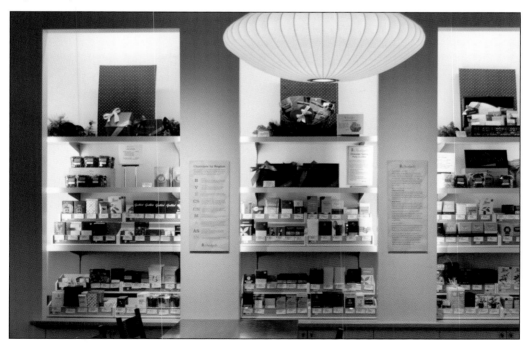

ASCONA CHOCOLAT SUISSE, BY LÄDERACH. The owner and proprietor of Ascona Chocolat Suisse, Hans Riechsteiner, was 23 years old when he left Switzerland to come to the United States. He has been selling gourmet European food for more than 30 years. Ascona Chocolat Suisse, his 14th business venture, specializes in elegant chocolates made by premier Swiss chocolatier Läderach. In the 1970s, Riechsteiner started selling Läderach-patented hollow truffle shells to pastry chefs in Seattle. Now, at Ascona Chocolat Suisse, he offers luxurious chocolates for the pampered palates of distinguished Seattleites. Here, one will find the Schachbrettli, a dark and light almond gianduja with a checkerboard design; the Cocobello, a domed coconut crème praline; and the Läderach Divine Red Heart, with white chocolate ganache flavored with apple liqueur enrobed in a white chocolate shell and blushed with red cocoa butter.

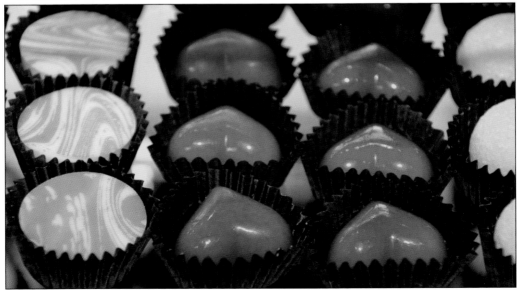

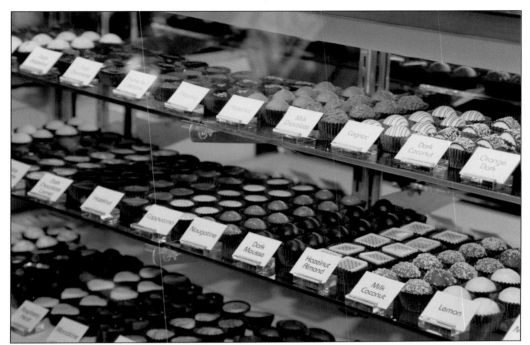

PREMIUM SWISS CHOCOLATES. The authors chatted with Hans Riechsteiner in his elegant Madison Valley chocolate boutique, Ascona Chocolat Suisse, where he receives weekly shipments from Switzerland. The Läderach Company, headquartered in the Swiss canton of Glarus, produces chocolate from bean to bar and is proudly connected to the Cabruca project for sustainable cocoa farming in Bahia, Brazil.

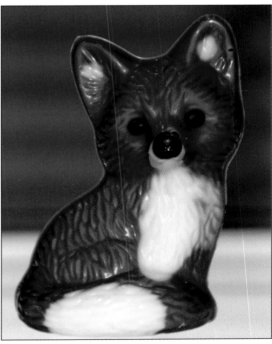

FIX THE CHOCOLATE FOX. Fix is lovingly featured and introduced on the Läderach website: "Our Läderach chocolatiers made a delicious chocolate fox with exquisite caramelized Piedmontese nuts for our most foxy epicures. An ideal gift for young animal lovers who will soon become fans of little Fix." A big fan of the little fox, Hans Riechsteiner told the authors the story of the real fox that lived in St. Moritz for 13 years and was the inspiration for Fix the chocolate fox. The Läderach Company created an edible memorial to the beloved little omnivore.

ADDITIONAL CHOCOLATIERS

While the following chocolatiers and shops are not featured in this book, they are certainly worth a visit from any chocolate-lover.

A SIMPLE TREAT
Cakes as well as truffles and chocolates; family-owned and -operated business from Kirkland
asimpletreat.com

BAKERY NOUVEAU, WEST
 SEATTLE AND CAPITOL HILL
Over 30 varieties of handmade chocolates, hand-dipped fruits, molded caramels, and enrobed ganache
bakerynouveau.com

BON BON CANDIES, BAINBRIDGE ISLAND
Chocolate shop serving sweet indulgences on the island
bonboncandies.com

CHOCOLATE NECESSITIES
Over 25 years of handcrafted chocolates in Bellingham
chocolatenecessities.com

DEIROS ARTISAN CHOCOLATES
Brazilian-inspired from Maple Valley
deiroschocolate.com

EVOLVE CHOCOLATE TRUFFLES
Small-batch chocolates with Pacific Northwest flavors from Bellingham
evolvetruffles.com

FIORI CHOCOLATES, SEATTLE
Italian-style, small-batch artisan chocolate confections
fiorichocolates.com

FORTE CHOCOLATES, MOUNT VERNON
Handcrafted chocolates and caramels by master chocolatier Karen Neugebauer
fortechocolates.com

KAKAO, SEATTLE
Espresso and hot chocolate drinks, bars, and truffles
kakaoseattle.com

OH! CHOCOLATE, MADISON PARK
Since 1985, three generations of chocolate-makers
ohchocolate.com

OH! CHOCOLATE, MERCER ISLAND
Since 1985, three generations of chocolate-makers
ohchocolatemercerisland.com

RESTLESS CHOCOLATE
Small artisanal chocolate company from Seattle
restlesschocolate.com

SWEET MONA'S, LANGLEY, WHIDBEY ISLAND
Chocolate shop with confections by chocolatier Mona Newbauer
sweetmonas.com